JOHN MOORES
25

CONTEMPORARY PAINTING PRIZE

NATIONAL MUSEUMS LIVERPOOL

Contents

Foreword 4

The jury 6

2008 prizewinners 9

2008 exhibitors 33

Index of artists 106

John Moores exhibition
fact file 1957 – 2008 108

Previous prizewinners 127

Foreword

John Moores and David Hockney at the 1967 exhibition

This exhibition marks the 25th John Moores Contemporary Painting Prize and 50 years since the first John Moores Liverpool exhibition was held at the Walker Art Gallery in 1957. It is gratifying and appropriate that in 2008 this coincides with Liverpool's year as European Capital of Culture. The record number of entries (3,322) this year demonstrates the excitement and importance of the John Moores as Britain's pre-eminent painting prize.

Although the appearance of each exhibition changes, the principles of the John Moores are constant: to support artists and to bring to Liverpool the best of contemporary painting from across the UK. As in previous years, this exhibition profiles the best established and emerging artists - today's John Moores Prizewinners and Exhibitors will be the future stars of the art world.

Since 1957 the John Moores Prize has enabled the Walker Art Gallery to build up a remarkable collection of works and with hindsight it is clear that it acts as a barometer of British painting practice. To mark the importance of these 50 years of activity, we are this year staging a related display of previous John Moores Prizewinners. This includes important works acquired for the collection such as those by Jack Smith and David Hockney and, more recently, by artists including Michael Raedecker and Peter Davies. This year's first prizewinner has been purchased for the Walker Art Gallery's collection and joins the distinguished group.

We would like to thank the Trustees of National Museums Liverpool, the John Moores Liverpool Exhibition Trust and members of the Moores family for their constant commitment, energy and support. We are grateful for the continued support of the A Foundation especially through their role as hosts for the first stage of judging in London and the use of their facilities in Liverpool for the second stage. The exhibition is sponsored by Business2008, National Museums Liverpool's corporate membership scheme. Radisson SAS Hotel Liverpool has again given support as official hotel partner. The Visitors' Choice Prize (£2008 for Capital of Culture Year) is sponsored by Rathbone Investment Management and Radisson SAS Hotel, Liverpool. We are delighted that a-n, The Artists Information Company, is our media partner this year. Thanks, finally, to the many staff at National Museums Liverpool who have worked to make the show a success.

Our particular thanks are due to the jurors: Jake and Dinos Chapman, Graham Crowley, Paul Morrison and Sacha Craddock. They worked enthusiastically and were rigorous in their task. As always, all the judging took place anonymously without the names of artists being revealed. The jurors were passionate about the final selection of 40 paintings for exhibition and were rightly confident that they have given us an up to the minute record of contemporary painting. We are delighted to present these works to you as an example of the sometimes surprising and always lively character and quality of British art today.

Lady Grantchester
John Moores Liverpool Exhibition Trust

Reyahn King
Director of Art Galleries, National Museums Liverpool

5

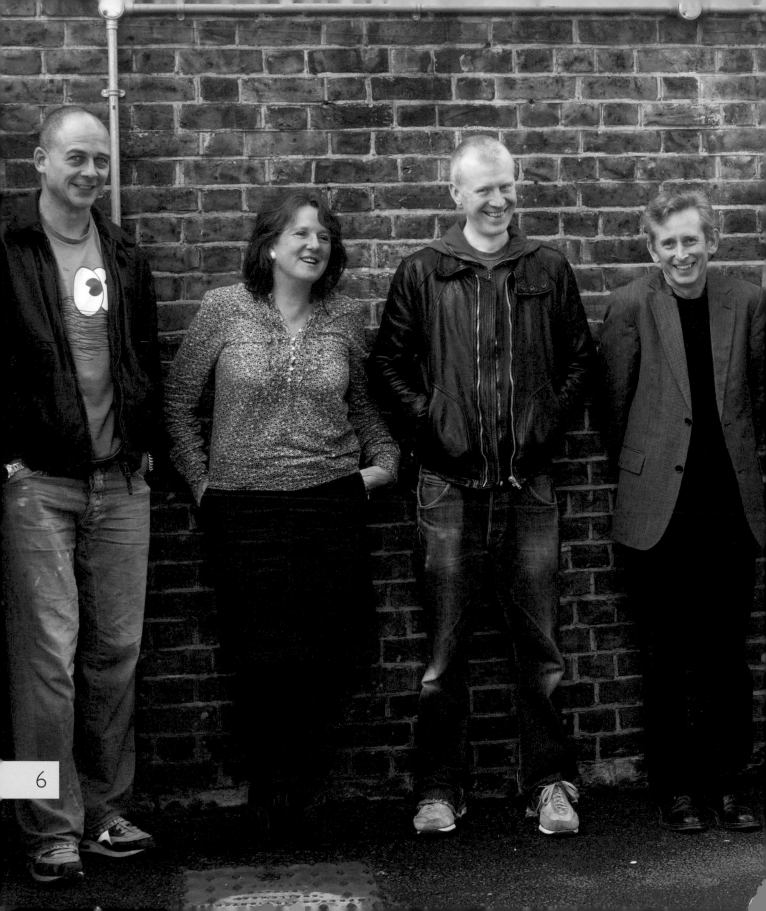

The jury

artists
Jake and
Dinos Chapman

art critic / curator
Sacha Craddock

artist
Graham Crowley

artist
Paul Morrison

left to right: Dinos, Sacha, Paul, Graham, Jake

8

First prizewinner
£25,000

Peter
McDonald

Peter McDonald

Fontana 2006

Acrylic gouache on canvas, 81 x 114.2cm

My paintings depict a colourful world inhabited by people engaged in everyday activities. Images of teachers, artists or hairdressers are constructed with an elementary graphic language. They have a cartoon-like simplicity and waver at the point where figuration might tip at any moment into abstraction.

Human forms veer towards the geometric: circles stand in for heads, flat planes describe rooms and crude poses denote narrative. These simplifications appear to create a community of super-humans living in a world that has a harmonious transparency.

By making use of archetypes, symbolism and our irresistible tendency to make the strange readable, this alternative world operates like a parallel universe, with a very familiar logic and practices.

This utopia may be a vision of an ideal world in the future or a simplified and optimistic version of the one we already know.

BIOGRAPHY Peter McDonald was born in Tokyo, Japan in 1973. He studied in London at Central Saint Martins 1992-95 and the Royal Academy Schools 1997-2000. He has exhibited widely, including at *EAST International* 2003 Norwich Gallery and *Portrait Session* Hiroshima Museum of Contemporary Art 2006. In 2007 he participated in *Like Color in Pictures* at Aspen Art Museum Colorado USA and had his second solo show with Kate MacGarry in London. During 2008 he has shown in *Imaginary Realities: Constructed Worlds in Abstract and Figurative Painting* Max Wigram Gallery London and will have his second solo exhibition with Gallery Side 2 Tokyo.

Peter McDonald | First prizewinner

Prizewinners
£2,500

Julian Brain

Geraint Evans

Grant Foster

Neal Jones

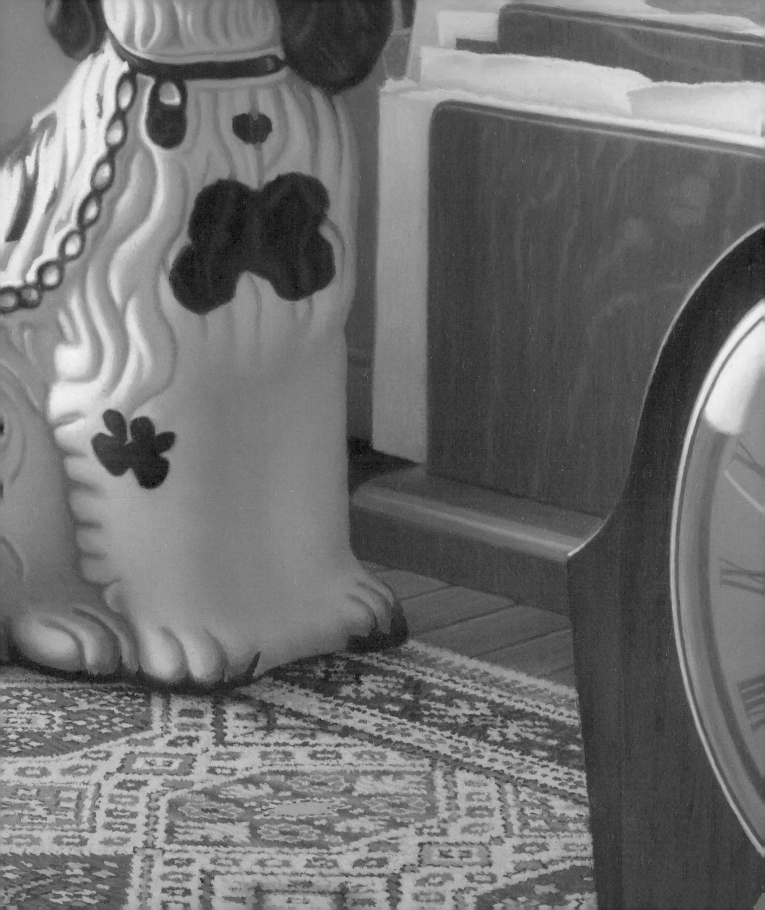

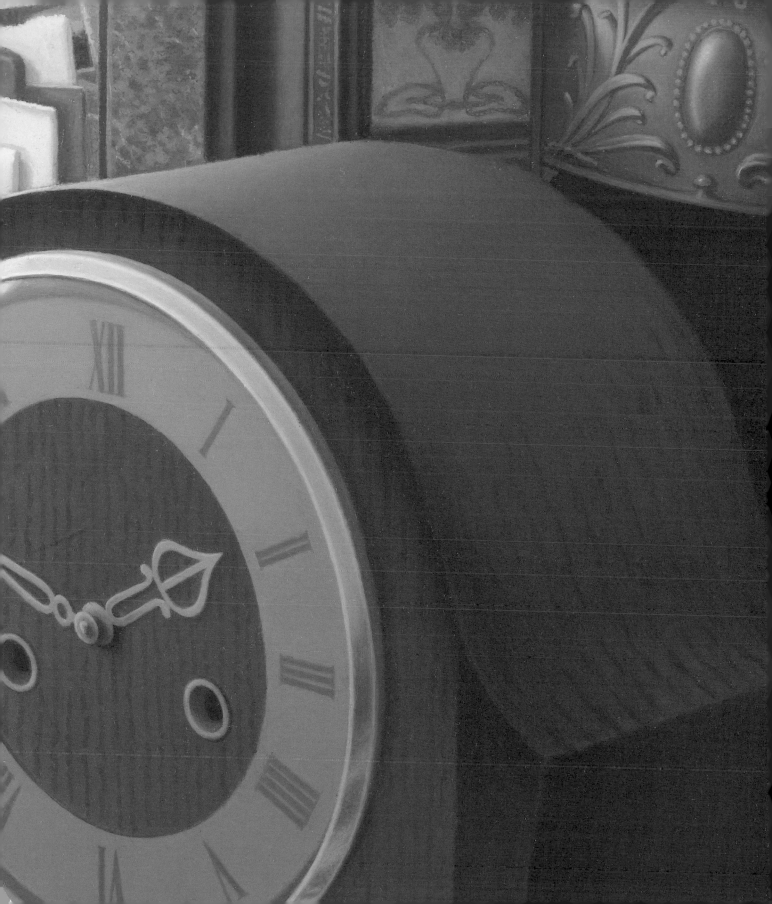

Julian Brain

Special Relativity 2000-07

Oil on linen, 72.5 x 83 cm

Special Relativity is set in the rearranged front room of my adoptive family home. Each of the enlarged objects in the room is related to, and represents, a member of that family: the clock stands for my father, and he is flanked by the china dogs representing his mother, my grandmother. The ball of wool, cotton reels and crochet needle stand for my mother; her parents, my grandparents, are represented by the letter-rack on the left of the fireplace, made by her father, and the embroidery of Sailsbury Cathedral on the wall above, sewn by her mother. The painting-within-the-painting, showing the same room with everything back in the right place, is an attempt to suggest the fractured self-awareness that having differing biological and sociological identities can create. The empty picture frame on the right represents my unknown genetic family, significant in their absence; it was from my biological father, a sign-writer and coach-painter, that I inherited the dexterity to paint this picture.

Biography Julian Brain was born in the Forest of Dean on the shortest day of 1958. He is an entirely self-taught artist and is currently based in Gloucester. He was an exhibitor in the *Celeste Art Prize 2007* finalists' exhibition at Old Truman Brewery London (touring to Edinburgh) and exhibited in the *Summer Exhibition* at the Royal Academy London in 2007 and 2008.

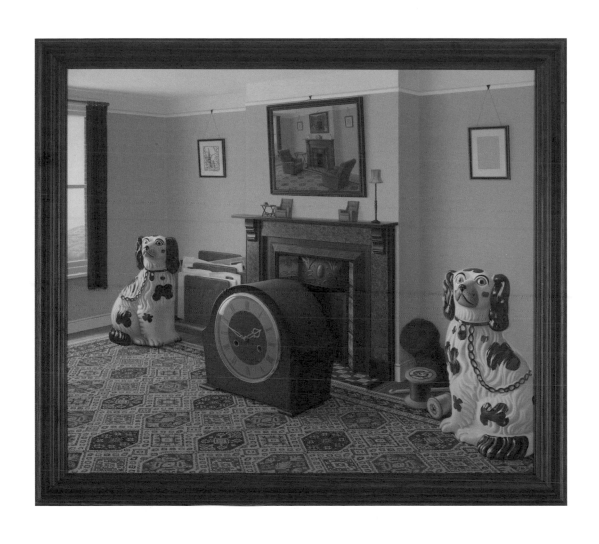

Julian Brain | Prizewinner

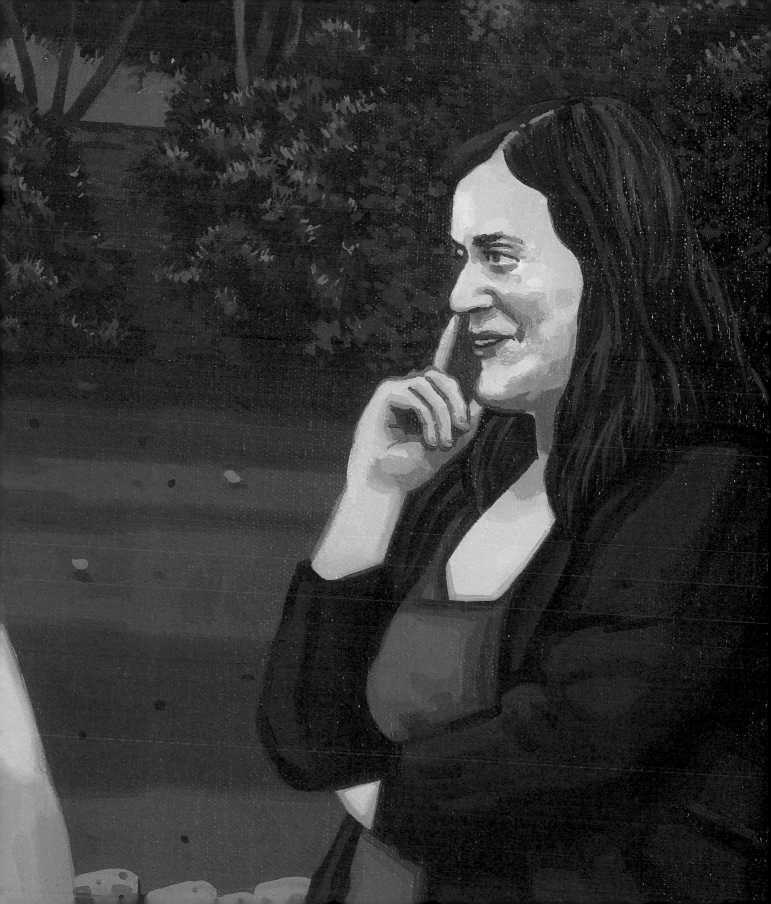

Geraint Evans

An Ornamental Hermit 2007

Oil on canvas, 150.5 × 173.5 cm

My narrative-driven paintings are often located in the British suburban landscape of convention and compromise. I am interested in how this is undermined, or defined, by small moments of creativity or idiosyncratic activities. Recent paintings respond to the writer Roger Silverstone's observation that the suburbs 'reconcile and deny the essential differences between urban and rural life.' (*'Visions of Suburbia'*, Routledge, 1996). They depict the simulated and constructed landscapes that are often found within the city and that offer safe and yet possibly aspirational encounters with 'authentic', uncultivated nature. *An Ornamental Hermit* references a peculiar development in the English landscape garden tradition that saw a number of 18th-century landowners advertise for a suitable candidate to reside within their grounds and to adopt the mannerisms and appearance of an archetypal hermit.

Biography Geraint Evans, born in 1968, grew up in Swansea. He studied at Manchester Polytechnic 1987-90 and the Royal Academy Schools London 1990-93. Solo exhibitions include Wilkinson Gallery London 2000 and 2004, Chapter Cardiff 2001 and CASA Salamanca Spain 2003. Group exhibitions include *Dirty Pictures* The Approach London 2003, *Other Times* City Gallery Prague 2004 and *Bittersweet* Whitworth Art Gallery Manchester 1997. He was resident artist at Banff Centre for the Arts Canada 1994 and received the *Berwick Gymnasium Fellowship* in 2002/3. Exhibited in *John Moores 19* 1995, *John Moores 23* 2004 and *John Moores 24* 2006. He is course leader for postgraduate painting at Wimbledon College of Art London.

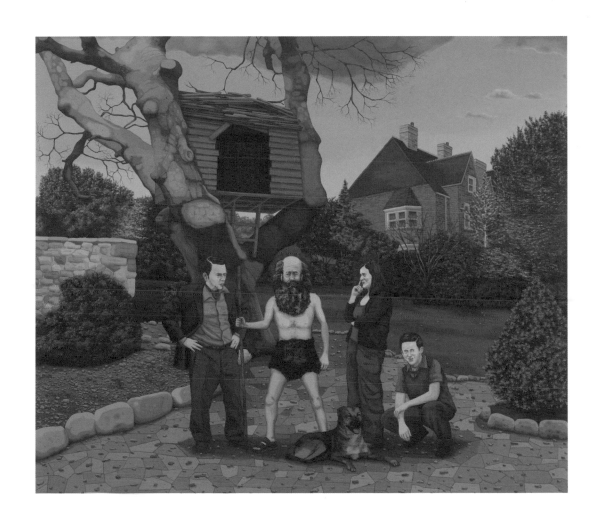

Geraint Evans | Prizewinner

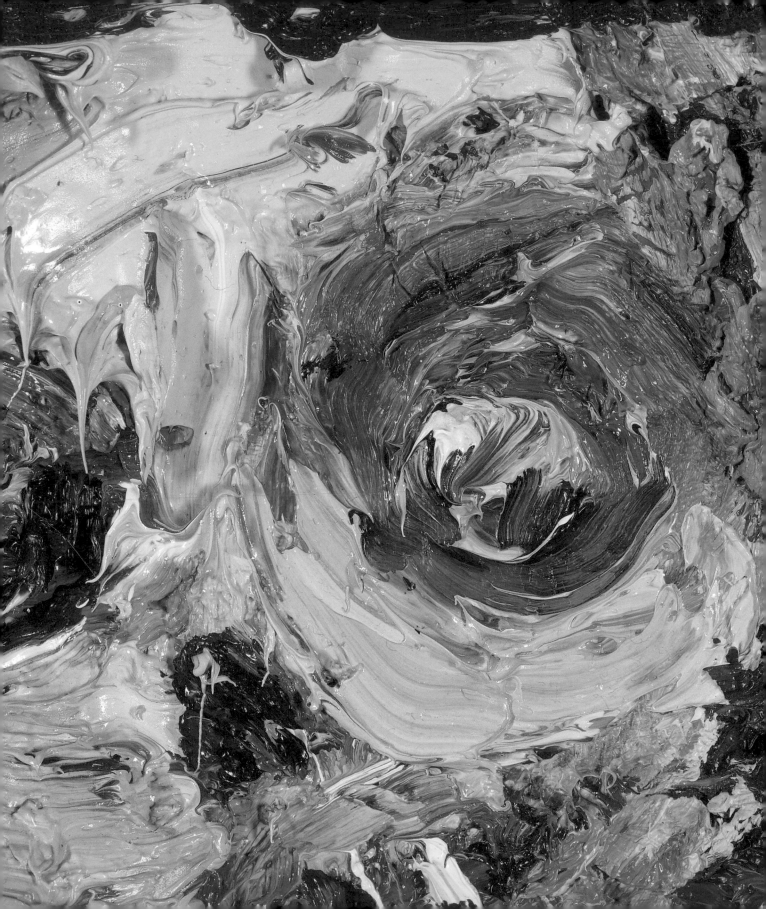

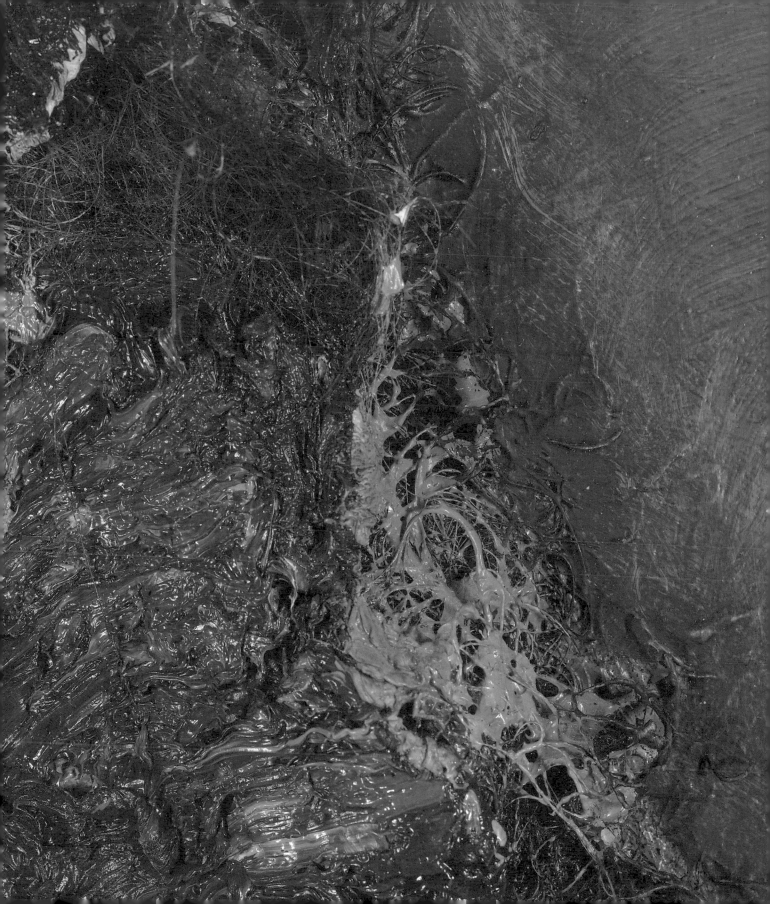

Grant Foster

Hero Worship 2007

Oil and human hair on board, 60.5 x 50.2 cm

The characters bare witness to the humanity found in extreme situations, while the painting indicates inhuman and barbaric practices, like butchery and torture. Characters have included soldiers and martyrs, types that are typically male, where the displacement and corruption of power occurs. They are fetishes of the grotesque that mark their territory by pissing on themselves and everyone around them.

I want the paintings to be read as human, however feeble or malevolent. The characters are both victim and villain, and self-portrait and fiction.

BIOGRAPHY Grant Foster was born in Sussex in 1982. He studied painting at the University of Brighton 2001-2004, winning the Burt, Brill & Cardens Award for Outstanding Artistic Excellence 2004. He attended The Prince's Drawing School London 2004-06, gaining the Drawing Year Bursary Award 2006. He was awarded the Winsor and Newton Art Prize 2006. Group shows featuring his work include *Bride of the Atom* Studio A Gallery London 2004, *Pathos to Ethos* Eleven London and *George Polke Invites* George Polke Gallery London, both 2006, *Big Wow* Oslo House London 2007 and *Dead Bodies and Cardboard* Elevator Gallery London 2008.

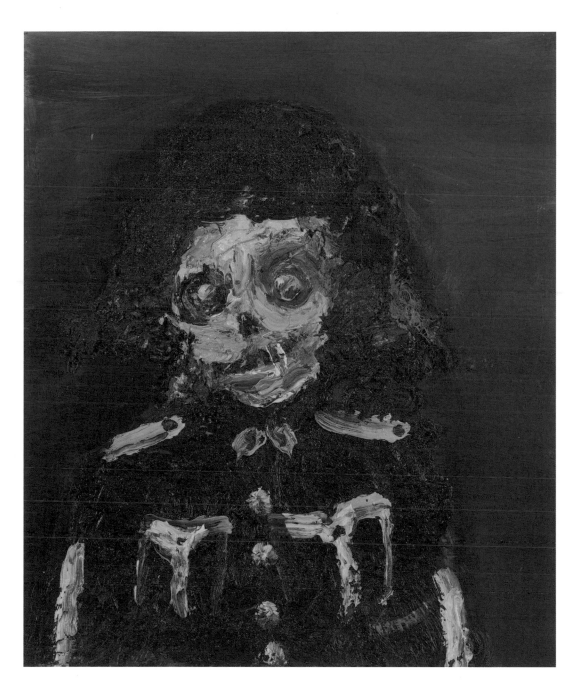

Grant Foster | Prizewinner

Neal Jones

Bruegel Camp 2007

Oil on wood, 42.7 x 31.2 cm

In my landscape painting I aim to strike a muddy balance between the romantic and the realistic.

After a disappointing camping trip to the Lake District, overpopulated with tourism and fudge, I was eager to communicate in *Bruegel Camp* the discomfort and humour of hopeful bodies in the wilds, sheltering in various ascetic modern pods.

In painting I look for the abstract and poetic. I often choose clumsy marks to decorate holy fools and to show nature as a battlefield, not picturesque but gothic and insanely rich.

I use a simple palette and humble materials and try to imbue them with magic and history. I am a fan of early religious art for its grounded structures and flights of the imagination.

BIOGRAPHY Born in Liverpool in 1969, Neal Jones was raised in Blackpool. He attended Canterbury College of Art and Design 1989-92. Since 2000 he has painted in a self-built London allotment studio. Following a bursary to study at The Prince's Drawing School London 2003, he taught there 2006. His exhibitions include *The Drawing Year* Alberto Vilar London 2004, *The Discerning Eye* Mall Galleries London 2005, *Travelling Drawings* Kensington Palace London 2008 and *Summer Exhibition* Purdy Hicks London 2008. *The Kindling Gallery,* his online landscape gallery and cooperative, launches in 2008.

Neal Jones | Prizewinner 31

Exhibitors

Georgina Amos

Tim Bailey

Richard Baines

Christopher Barrett

David Bowe

Tom Bull

Louisa Chambers

Clare Chapman

Jake Clark

Sam Dargan

Damien Flood

Jaime Gili

Gabriel Hartley

Georgia Hayes

Gerard Hemsworth

Roland Hicks

Ian Homerston

Stephanie Kingston

Richard Kirwan

Mie Olise Kjærgaard

Matthew Usmar Lauder

Geoff Diego Litherland

Marta Marcé

Michelle McKeown

Eleanor Moreton

Alex Gene Morrison

Kit Poulson

Sista Pratesi

Ged Quinn

Neil Rumming

Robert Rush

Michael Stubbs

Matthew Wood

Stuart Pearson Wright

Vicky Wright

Georgina Amos

No Place 2007

Acrylic paint and plastic packaging on linen, 150 x 150 cm

Painting's inescapable relationship to surface has inspired my recent work. The medium is not separate, but describes the content. I form a relief by sticking discarded packaging on to the canvas, and then layering on a surface of acrylic colour to create a new aesthetic reading of the object. Painting over the surface of the packaging serves to reveal its shape while simultaneously concealing what may be behind it.

Camouflage and secrecy has become important in my investigation of communicating through visual means. Through the surface I emphasize the oscillation between the illusion of making a flat image seem three-dimensional and the reality of the material.

Building up further layers of paint and masking areas at each stage, I finally peel away these areas to reveal the image. The work is hidden to me for the duration of making the painting. The shapes I mask are derived from amalgamations of forms I see in the world and are unrecognisable as any specific entity, lying between the figurative and the abstract. I am particularly interested in objects which do not communicate visually, such as satellite dishes and telephone wires, and in using their visual forms to explore and re-build new understandings of their original function.

BIOGRAPHY Georgina Amos was born in Cambridge in 1982. She studied at Chelsea College of Art and Design London 2001-04 and will attend The Slade School of Fine Art London 2008-10. Exhibitions include *Kettle's Yard Open 2004* Kettle's Yard Cambridge, *Abstract Landscapes Exploring Communication in Painting* (solo) Churchill College Cambridge 2005, *Abstract Paintings Questioning the Possibility of Communication* (two-person) Toni Heath Gallery London 2005, *Gilchrist Fisher Award* (2nd prize) Rebecca Hossack Gallery London 2006, *Enclosed Gardens* Long & Ryle Gallery London 2006, *Art is Abstract* CCA Cambridge 2007. Shortlisted, *Celeste Art Prize* 2006. Work is in the collections of Cambridge University and Chelsea College of Art.

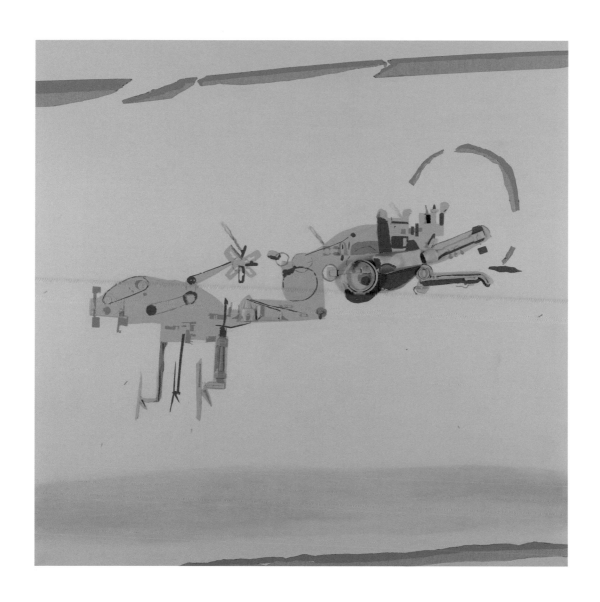

Georgina Amos

Tim Bailey

Cadet Congo Ganja 2007-08

Oil on canvas, 40.5 × 30.5 cm

The title of this painting was produced with internet software used to form Jamaican Creole names from English names. The phrase suggested a fusion of Mr Kurtz from Conrad's *'Heart of Darkness'* and Colonel Kurtz from Coppola's *'Apocalypse Now.'* In the novella, Kurtz was an ivory-trader on the Congo, while in the film he was an American soldier illegally encamped in Cambodia during the war in Vietnam. My Kurtz, *Cadet Congo Ganja,* is a cultural composite, a bust-portrait of a bald young Caucasian wearing the uniform of a West Point military cadet, his face modified by war paint that is part clown and part warrior.

My knowledge that Edgar Allan Poe was also a cadet at West Point (before his court-martial) may somehow have influenced this painting, which is from a series of portraits of members of a fictional colonial family, *'The Rial Family.'* The word 'Rial' ('royal' in English) is a modifier used by Jamaican Creoles to denote children of mixed ethnic parentage. It refers to the Jamaican parent; so, for instance, Chinese/Jamaican becomes Chiney-Rial. We arrive at this version of Kurtz-Royal, opaque and as impenetrable as a joke told in a foreign language.

BIOGRAPHY Tim Bailey was born in Flitwick, Bedfordshire in 1966. He attended Central Saint Martins London 1985-88. He has exhibited in group shows including *Near* Sharjah Museum of Art United Arab Emirates 1998, *Slimvolume 01* Austrian Cultural Institute London 2001, *Like Beads On An Abacus Designed To Measure Infinity* Rockwell London 2005, *Frozen Tears III* (book launch) Koenig Books London 2006 and *990: General History of Other Areas* Beacon Art Project Mablethorpe Lincolnshire 2007.

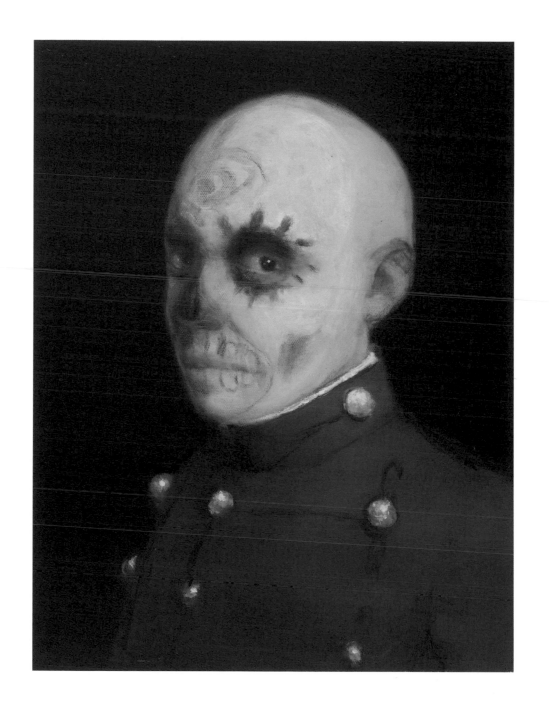

Tim Bailey

Richard Baines

Mickey's Trailer 2007

Oil and gloss on canvas, 47.2 x 64.3 cm

The paintings I create are narrative constructions assembled from elements extracted from many different sources including my own drawings, photographs and found images. The images I make tell of obsessive behaviours, uncomfortable circumstances and uneasy solitude. The fractured origins of the stories presented unite with the stillness and expectancy of something waiting to happen to create an overwhelming feeling of discomfort that will never be satisfied by an actual event.

BIOGRAPHY Richard Baines was born in Bath in 1981. He studied at the City of Bath College 2000 and at Falmouth College of Arts 2002-05. In 2008 he commences an MA in Painting at the Royal College of Art London. His solo and group shows include the *Showtime* series Falmouth 2005 (solo), *Superlative 5* Plymouth Arts Centre 2005, *The Discerning Eye* Mall Galleries London 2005 (regional prizewinner) and *Bath Society of Artists Summer Exhibition* Victoria Art Gallery Bath 2006 and 2007. He reached the final round of judging in the *Jerwood Contemporary Painters Prize* 2008.

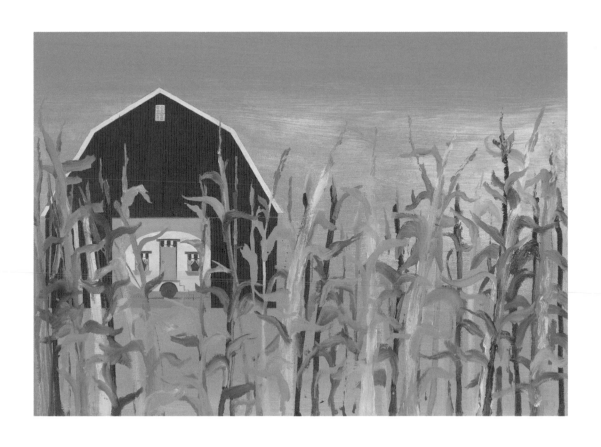

Richard Baines

Christopher Barrett

Pirosmani in Tbilisi 2008

Oil on canvas, 61 x 76 cm

Pirosmani in Tbilisi is the result of a visit to the state museum in the capital of the Republic of Georgia. A room is devoted to the work of Niko Pirosmani and I wanted to let the characters he painted occupy the space of the room. It took some time for this group of men at a banquet to make their way from one painted world into another.

My paintings endeavour to be visual representations of my everyday experiences. I am trying to bring together visual observations and emotional responses. These attempts to fuse together parallel worlds to form a coherent visual language have led to an interest in pictorial representation of space and light. Through painting I am, in a sense, trying to take possession of the space I occupy and experience.

BIOGRAPHY Christopher Barrett was born in London in 1954. He attended Bath Academy of Art Corsham 1973-76. Solo shows include *Christopher Barrett* Bampton Art Centre Oxfordshire 1977, *Christopher Barrett Paintings and Drawings* Bloomsbury Way Gallery No 1 London 1982 and *33 Paintings of Chastleton House* Manor House Gallery Chipping Norton 1989. He was *Hospital Artist-in-Residence* Barrow in Furness 1993-4 and Muir Trust *Artist-in-Residence - Revealing Interiors* Buckinghamshire County Museum Aylesbury 1998. Group shows include *Midland View 3* Mansfield Art Gallery (touring) 1984-5, *A Century of Art in Oxford* MOMA Oxford 1992, *Worthing Open Art* Exhibition (1st prizewinner) 1997 and *Off the Wall* BCM Aylesbury 2006.

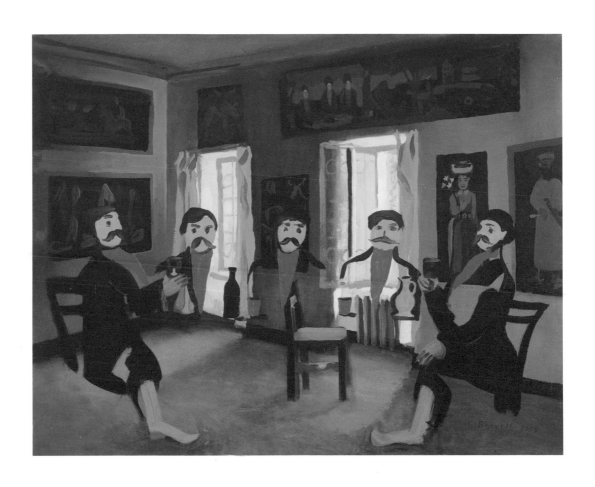

Christopher Barrett

David Bowe

Obst & Gemuse 2007

Oil on canvas, 25.2 x 30.5 cm

My paintings are subdued, discreet glimpses, sometimes of mundane occurrences, sometimes of dormant, poised states of time and place. I am interested in the nuances of our relationship with the infrastructure of the everyday, often in the context of travel and urbanity, and the impact these surroundings have on our sense of self.

The recurring sub-themes are the uneasy duality of alienation through interaction, of people removed and absorbed in a private world whilst in the company of others; of company without companionship and how the solitude of a person's internal landscape can seem reflected back in the internal landscape they inhabit.

The subjects in my paintings often appear as overlooked and forgotten elements in an absent narrative; stills removed from their film. I think of them as vignettes capturing moments and atmospheres of anticipation, abandonment and lives lived just out of view, of being the accumulation of activity and inactivity that create a sense and mood of place.

BIOGRAPHY David Bowe was born in Preston in 1965. He studied at Sheffield City Polytechnic 1983-86 and undertook a studio residency there 1986-87. He attended Glasgow School of Art 1987-88, including a Student Residency Exchange to the Maryland Institute Baltimore USA. His exhibitions include the group show _Wall to Wall (Part I)_ Seven Seven Gallery London 2005.

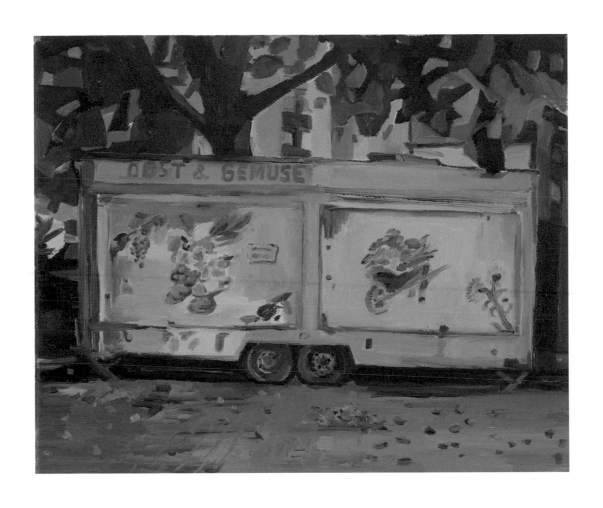

David Bowe

Tom Bull

Black Flag 2007

Oil paint on shaped MDF, 20 × 25 cm,

My interest in painting is derived from having encountered the quietness and grace of 18th-century Japanese landscape painting. I endeavour to paint with a muted form of expression. Huts on stilts, raised walkways, A-frames, ladders and billboards litter the fictitious landscapes. They are the traces of human existence (human idiosyncrasy), but they also act as technical devices, making the landscape somehow more tangible.

BIOGRAPHY Tom Bull was born in Shoreham, West Sussex in 1983. He studied at Brighton and Hove City College 2001-02 and Middlesex University 2002-05. Since graduating he has shown in London in group shows including *Middlesex University Degree Show* Old Truman Brewery 2005, *You don't have to murder your father* The Empire 2005, *Best of the Best and Art in Mind* La Viande 2005, *Jam* John Jones Project Space 2006 and *Square Eyes* John Jones Project Space 2007.

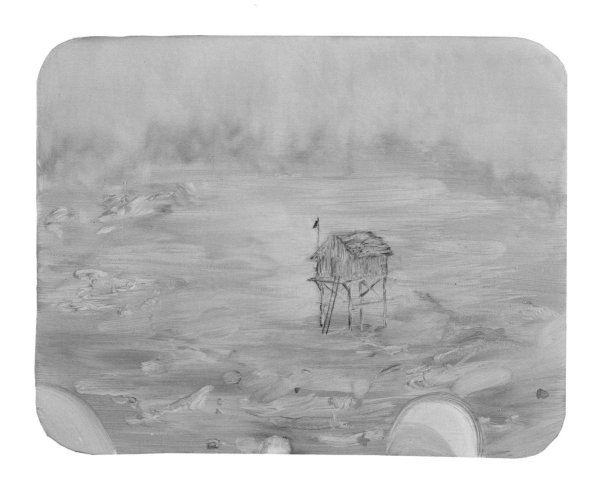

Tom Bull

Louisa Chambers

Mechanical Coat 2008

Acrylic and oil on canvas, 50.2 x 40.3 cm

Constructing with shapes influenced by games, architecture and technology are often starting points within my recent practice. When painting, the shapes transform into joining blocks which, when slotted together, become ridiculous inventions. These inventions are often symbolic to my own personal narratives and dream spaces. Sometimes they are humorous due to their playful aesthetic. Often they are clunky and fragile, never being able to function. They originate from sources derived from modernist ideals concerning play and objects that assist humans in a temporary, placeless world.

In particular *Mechanical Coat* becomes alive and functional when one puts it on. If you are threatened it is able to shoot out substances through the holes of the coat. In contrast with modernist utopian ideals, *Mechanical Coat* conjures up dystopian feelings where the object is threatened in the space as it is under attack and needs protection. I enjoy this conflict between ideas and realisation but also the friction of falling in and out of personal dreamscapes.

BIOGRAPHY Louisa Chambers was born in Northampton in 1983. She attended Surrey Institute of Art and Design 2001-05 and the Royal College of Art London 2005-07. She lives and works in London, where she has exhibited in group shows *Matches and Petrol* A & D Gallery 2006, *The Great Exhibition* Royal College of Art 2007, *My Penguin 39* 2007 and *East End Arts Show* Shoreditch Town Hall 2007. In 2008 she was included in *I Regret to Inform You* Madam Lillies London and *'00 Nature* Contemporary Art Projects London.

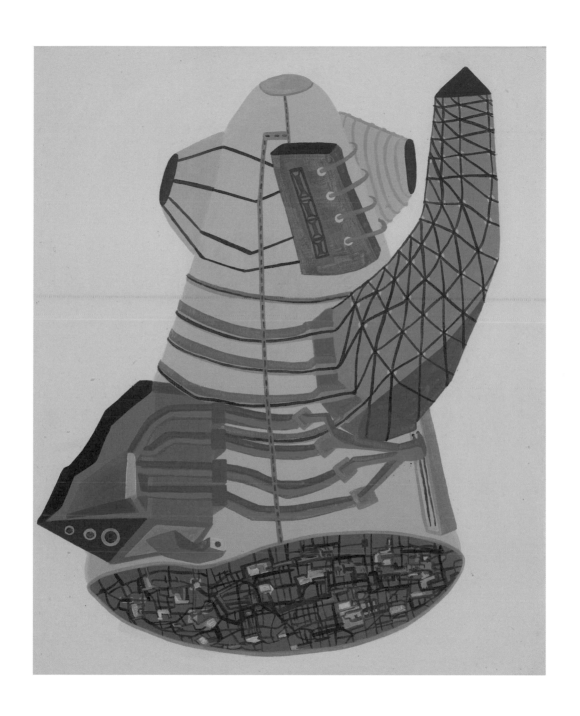

Louisa Chambers

Clare Chapman

Still Life, No. 2 2007

Oil on canvas, 102 × 140 cm

I arrive at the imagery in my paintings by starting them pretty chaotically. I enjoy gradually squeezing out and uncovering forms and textures suggested in quite random paint marks, and then refining or disturbing these with each new layer.

There is, I think, quite a bit of unpleasantness in my paintings. It's this feeling that determines what shapes I pull out of the paint. It lurks beneath the surface in the paintings, and through the loving execution of this surface, it finds itself bubbling up, pushing its way out through abject bulges and hollows.

In the end, I want the paintings to remain uncertain. They depict something that you want to place somewhere, but owing to their inherently abstract nature you are frustrated in doing so.

BIOGRAPHY Clare Chapman was born in Chertsey in 1974. She studied at Kingston University London 1992-93, Falmouth College of Arts 1993-96 and The Slade School of Fine Art London 1999-2001. Group exhibitions include *Sufficient Forms* East 73rd Gallery London 2001, *Rising to the Surface* Gallery Westland Place London 2001, *Outside Gets Inside* James Hockey Gallery West Surrey Institute of Art & Design 2002, *Art Futures* (Contemporary Art Society) London 2003, *What Happened Next?* Sarah Myerscough Fine Art London 2003 and *Dolores* Sartorial Contemporary Art London 2004. She gained the Gordon Luton Prize (Worshipful Company of Painter-Stainers) 2001 and the British School at Athens' Prince of Wales Bursary 2004.

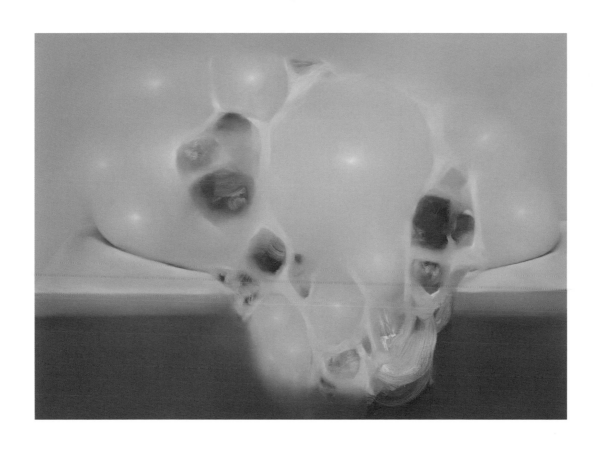

Clare Chapman

Jake Clark

Cornerways 2007

Oil and fablon on canvas, 90 x 115.3 cm

Cornerways is part of a series of paintings focusing on a fictional seaside place. This place is a holiday utopia that has seen better days. My main subject matter at the moment is bungalows. These interest me because they act like modernist blocks in the landscape and suggest a particular atmosphere. I like the way that in English coastal towns the buildings have a kind of faded quality.

To make the work I begin by sticking vinyl patterns to the surface of a painting. Abstract marks are laid on top of these. An image made from collaged photographs is then painted over this ground. Parts of this vinyl are left uncovered and could represent the interior decor of the buildings depicted. I take my own photographs in strong sunlight to bring out the colour and shadows. I am fascinated by how a photograph can be broken up and rebuilt during the painting process.

Resorts have always been a pivotal part of my work. These recent paintings are a continuation of this. I am trying to create a sense of sun-drenched nostalgia with some sort of impending doom. In Bret Easton Ellis's recent novel *'Lunar Park'* he talks about the paint peeling off a present-day house, revealing his childhood house underneath. There is a blurring between fiction and his own past. Via collage, pattern and painting styles, I am attempting to deal with similar sorts of ideas.

BIOGRAPHY Jake Clark was born in London in 1966. He attended Falmouth School of Art 1985-86, Derbyshire College (photography) 1986-89, Brighton Polytechnic 1989-91 and the Royal College of Art London 1991-93. Exhibitions include *Reverse Engineering* Pearl London 2002, *The Lone Ranger* James Coleman Gallery London 2003, *Emergency* Aspex Gallery Portsmouth 2004, *The Vernacular* Standpoint Gallery London 2005, *Dog Days* (solo) Gasworks Gallery London 1995, *Drip Grot* Foster Art London 2006, *O Dreamland* Greatstone Kent 2007 and *The Painting Room* Transition Gallery London 2008. He exhibited in *John Moores 18* 1993 and *John Moores 22* 2002.

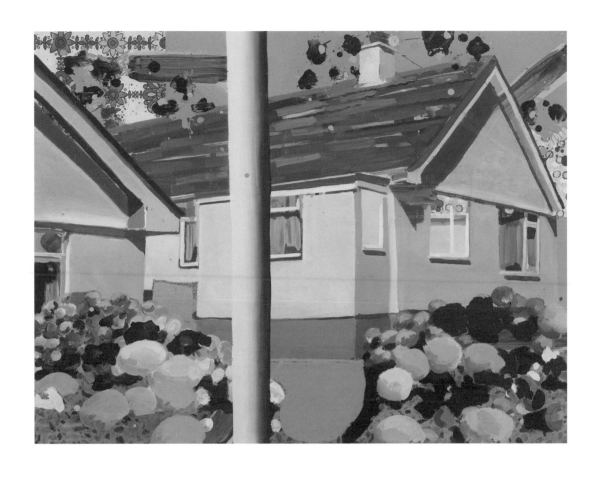

Jake Clark 51

Sam Dargan

Middle Management Meltdown 2008

Oil on board, 30 x 23 cm

For some time I have made work that I want to resonate with my own experience in the workplace. The characters in my paintings are often drone-like, shown in humdrum settings at times of extreme personal or social disaster. It's the monotony of the protagonists' existence against the extraordinary circumstances they find themselves in that provides the dark humour in my work. I want the viewer to have a grudging respect for my protagonist and at the same time an antipathy towards the jobsworth. Visually, my painting has to have a deadpan quality to highlight the abjection and futility the character is experiencing.

BIOGRAPHY Sam Dargan was born in Margate in 1971. He studied at KIAD Canterbury 1991-94 and the Royal College of Art London 2000-02. Group exhibitions include *'Now is Good' (ne travaillez jamais)* Northern Gallery for Contemporary Art Sunderland 2004, *The Darkest Hour* Mogadishnu Copenhagen 2005, *If you go down to the woods today* Rockwell London 2005. Solo shows are *The Unspeakables* Prenelle Gallery London 2004 and *A Bad Year for People* Rokeby Gallery London 2007 (Rokeby solo show forthcoming 2008). He won the *Oriel Mostyn Prize* 2006 and has taught at UCCA Canterbury and the Estonian Academy of Fine Art Tallin.

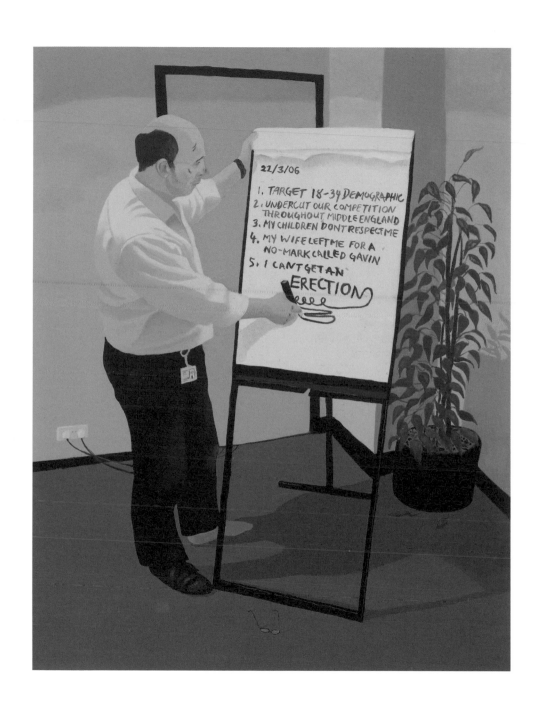

Sam Dargan

Damien Flood

Uncharted (Island II) 2008

Oil on canvas, 25 × 30 cm

My work deals with notions of the real and the unreal. I am interested in the idea of other worlds and places. My paintings are modern landscapes that reference the history of painting with an underlying fantastical element. A fleeting familiarity can be found in them, which is soon replaced by an ambiguous questioning.

A lot of my work stems from the voyages of the H.M.S. Challenger, a ship that explored the oceans in the 19th century. Notions of new and uncharted places play heavily in my work; how new places and islands are perceived for the first time. Those feelings of confusion and wonderment are sensations I want to evoke from the viewer. My influences stem from old films, 19th-century drawings, old masters and contemporary painters to objects lying around the studio.

Uncharted (Island II) evolved from a train ride home from my studio. As I looked out of the window I could see the hill near where I lived covered in a mist. Only the top of it, on which stands a giant stone cross, could be seen. This, for me, had that otherworldly, almost childlike mystery to it.

BIOGRAPHY Damien Flood was born in 1979 in Bray, Co. Wicklow. He studied at Dun Laoghaire Institute of Art, Design & Technology Co. Dublin 1999-2003 and the National College of Art and Design Dublin 2006-08. Group shows include *Big Store* Temple Bar Galleries Dublin 2007, *Iontas Sixteenth National Small Works Art Exhibition* Sligo Art Gallery (touring) 2005, and two-person shows *Projector* The White Room Gallery Galway 2006 and *Cellscape* County Council Arts Office Co. Wicklow 2008. Solo shows are *War on Art* Signal Art Gallery Bray Co. Wicklow 2004 and *Libertine* The Crow Gallery Dublin 2006.

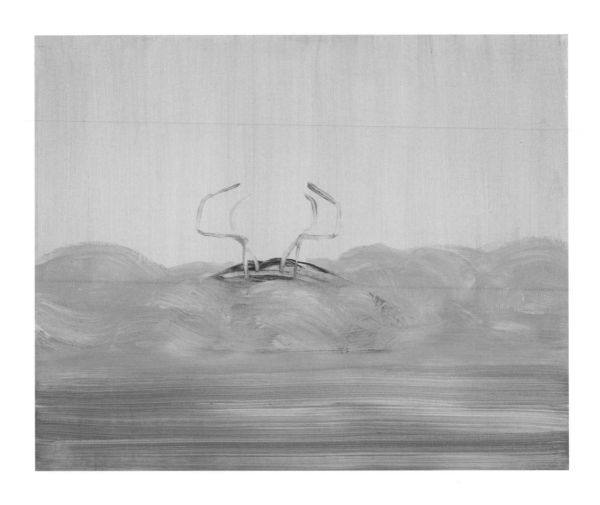

Damien Flood

Jaime Gili

A132 (AKIKO) 2008

Acrylic on linen, 70.3 x 56.5 cm

I grew up in Caracas at the peak of a very singular local modernity in art and architecture, in a tropical and multicultural city full of urban art and great architecture, full of optimism and character; a city built by artists and architects working together in a single dream fuelled by a strong oil economy. I started my art studies in Caracas as I witnessed the slow dismantling and ruin of some of the city's best institutions, buildings and urban art.

In my recent series of paintings I depict what could possibly be this clash of utopia and reality. I am also continuously developing projects that cross over and link artists and art projects in Europe and Latin America.

BIOGRAPHY Jaime Gili was born in Caracas in 1972. He studied at Prodiseño, Caracas 1989-90, Facultad de Bellas Artes, University of Barcelona 1990-95, Royal College of Art London 1996-98, and took a PhD at the University of Barcelona 1995-2001. Solo shows include *RUPT* Jerwood Artists Platform Jerwood Space London 2003, *Screen* Mosaic Building Miami 2005, *Las tres Calaveras* Periférico Caracas 2006 and *Superestrellas* Riflemaker London 2008. Group shows include *EAST International 1999* Norwich Gallery, *Villa Jelmini. The complex of respect* Kunsthalle Bern 2006, *Indica* Nyehaus New York 2007, *6a Bienal do Mercosul* Porto Alegre 2007 and *Jump Cuts* CIFO Miami 2007.

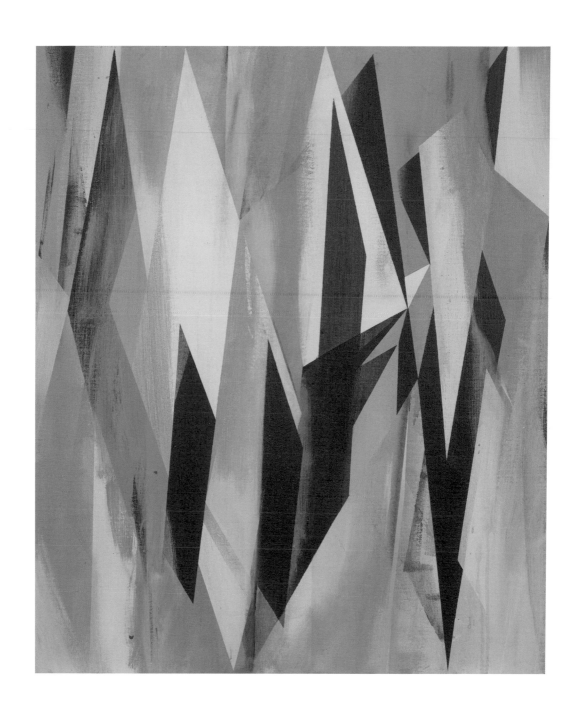

Jaime Gili

Gabriel Hartley

Dog 2007

260 x 200 cm, Oil, acrylic and gloss on canvas

I make paintings, ceramics, wood carvings and painted photographs. The starting point is an image or a real item, which then becomes abstracted. My reaction to the source either copies and mimics parts of it, or acts to deny and change its presence. The object sometimes changes to the point that it becomes a completely different entity, for example the starting point may be a necklace but the image changes to that of a dog on wheels. My paintings are concerned with the abstract and abstraction and with the history of abstract paintings and sculpture. They are painted with thick, heavily layered paint, which at times stands as a short hand for authenticity and questions the nature of authenticity in painting.

BIOGRAPHY Gabriel Hartley was born in London in 1981. He studied at Chelsea College of Art and Design London 2002-05 and at the Royal Academy Schools London 2005-08. Recent exhibitions include *Harvest* Long and Ryle London 2005, *Touch* Chelsea Future Space London 2007, *Influx* Nolia's Gallery London 2007, *Straight Edge* La Viande London 2007, *Bloomberg New Contemporaries 2007* Club Row Rochelle School London (touring) and *New Paintings* Parade Space London 2008. He was included in the *Summer Exhibition* Royal Academy London 2006 and 2007.

Gabriel Hartley

Georgia Hayes

Oportuno III 2007

Oil on canvas, 183.5 × 244 cm

I met Oportuno in Ibiza three years ago. I bought him but it took me some months to do the deal and then get him home. It was risky as he was unknown but luckily he is even better than I thought he might be. After a while I began to think of trying to paint him. I'd had a 6 × 8 foot canvas for years and I thought I might use it for the horse. Then it seemed too hard to do so I waited and put it out of my mind. I was in the middle of painting a series on animals in Africa. One day, on impulse, I went into the studio and started painting the horse. It is more or less life size. The process of buying the horse was much the same as the way I try to paint. I go along with gut feelings, overcoming fright, trusting intuition and hoping for nice surprises. In the past my paintings have usually had humans in them but this painting, although domestic, belongs with the recent work on African animals.

BIOGRAPHY Georgia Hayes was born in Aberdeen in 1946. She studied with painter Roy Oxlade 1977-82. Group exhibitions include *3x2* The Nunnery London 2002, *East & South 1992* Norwich Gallery and 15 *Summer Exhibitions* at The Royal Academy London 1987-2007. Solo shows include *Georgia Hayes Paintings* SFMOMA Artists Gallery USA 2002, *Georgia Hayes Paintings & Drawings* Frederick Spratt Gallery San José CA 2003, *What is Any Thing?* Cafe Gallery Projects London 2003, *Georgia Hayes: Obra Escogida, Dibujaos Y Pinturas* Galeria Nacional Costa Rica 2006 and *Seeing the Wood for the Trees* HQ Gallery E Sussex 2008. She exhibited in *John Moores 18* 1993.

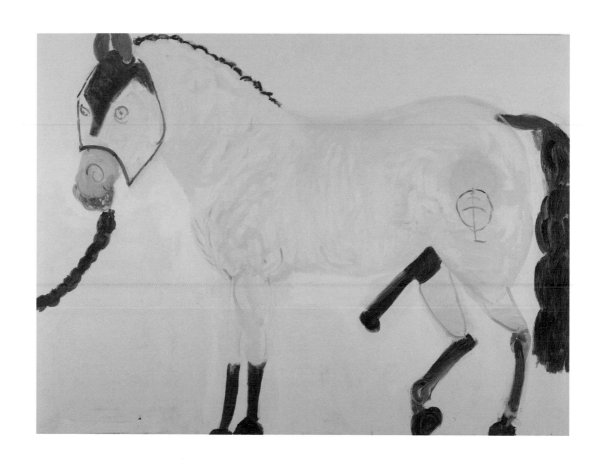

Georgia Hayes

Gerard Hemsworth

Frightened Rabbit 2007

Acrylic on canvas, 212.5 × 228 cm

How does art retain its value and remain questioning and critical? How does it avoid being merely a product of the time in which it was produced, easily consumed and assimilated, and like newness, transitory and replaceable?

Clearly, innovation is not enough. For new art to remain significant and continue as a viable proposition, it must continue to critically engage, which means it has to transcend the circumstances which enabled it to be produced in the first place.

For artists, the recognition of value is often a leap of faith.

Gerard Hemsworth

Roland Hicks

Sometimes We Sense the Doubt Together 2006

Oil on canvas, 153 × 122 cm

I'm interested in taking banal everyday items and then throwing their status into confusion by lavishing inappropriate levels of attention on them. *Sometimes We Sense The Doubt Together* is one of a series of paintings documenting the amorphous forms created by the convergence of shoe sole, hot pavement and discarded gum. I hope the resultant image retains its mundane origins while simultaneously suggesting a collision of anatomy, geology, pop-culture, abstract expressionism, sci-fi/fantasy and *memento mori*.

BIOGRAPHY Roland Hicks was born in Aldershot in 1967. He attended West Surrey College of Art & Design 1986-87, Winchester School of Art 1987-90, The Slade School of Art London 1994-96, and undertook a Fine Art Research Fellowship (Painting) at Cheltenham College of Art 1997-98. Solo exhibitions are *New Paintings 97-99* Gallery London 1999, *I Can't Help Myself* The Market London 2002, *Nothing Can Stop Us Now* Hiscox Artprojects London 2003 and *Give Me Every Little Thing* Oriel Davies Gallery Newtown (touring) 2007. Group shows include *NatWest Art Prize* (runner-up) Lothbury Gallery London 1999 and *BlowUp - New Painting and Photoreality* St Pauls Gallery Birmingham 2004.

Roland Hicks

Ian Homerston

Four 2008

Oil on board, 40 x 30 cm

The four icons in this painting are intended to represent recessive spaces of various depths, seen from various viewpoints. I made several drawings of this image in preparation, although the actual painting still required numerous adjustments and corrections before it was satisfactorily finished.

BIOGRAPHY Ian Homerston was born in Truro in 1984. He studied at Truro College Cornwall 2003-04, Wimbledon College of Art London 2004-07, where he was awarded *The Prunella Clough Scholarship* 2006, and since 2007 has attended the Royal College of Art London. He has exhibited in *Hans Brinker Trophy* Hans Brinker Hotel Amsterdam 2005, *Swell* La Viande London 2006, *Sculpt Paint Vomit Faint* temporarycontemporary London 2006, *Chop, Chop* Bartlett's Gallery London 2006, *One Love: The Football Art Prize* (winning 2nd prize) The Lowry Salford 2006/07, *Deserter* Gallery-33 Berlin 2007 and the *Summer Exhibition* Royal Academy of Arts 2007 and 2008.

Ian Homerston

Stephanie Kingston

252 Solitude 2007

Oil on canvas, 182.5 x 213.5 cm

The spaces of memory, through their painterly reconstruction, can offer liberation or entrapment. The act of painting late at night, attempting a lucid realisation of place, one part known yet twisted by remembering, has on this occasion produced a 'cell'. Pattern becomes the fetters; wallpaper and paste hide and reveal the code of isolation. The over-lit realm of personal surveillance augments the experience of insomnia.

BIOGRAPHY Stephanie Kingston was born in London in 1968. She studied there at Camberwell College of Arts 1986-87, The Slade School of Fine Art 1987-91 and Chelsea College of Art 1993-94. Group shows include *Making a Mark* Mall Galleries London 1996, *The Poster Show* Cabinet Gallery London 2000, *Pattern Crazy* Crafts Council London 2002, *Hunting Art Prize* The Royal College of Art London 2003 and *Miniatures* Kyubidou Gallery Tokyo 2003. Solo shows include Alternative Arts London 1993, 1997 and *Visual Departures* Limelight Gallery London 1997. Awards include *The Swiss Bank Corporation European Painting Prize* (British winner) 1994. She currently teaches at The Godolphin and Latymer School London.

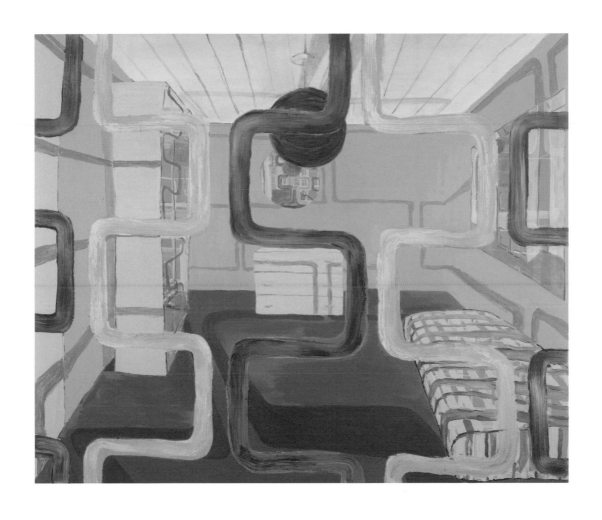

Stephanie Kingston

Richard Kirwan

As Above, So Below 2007

Acrylic on canvas, 203 × 203 cm

When I am thinking about painting, I might refer to a variety of contradictory statements by other artists, for example, Marcel Duchamp's distillation of painting as 'retinal, precision optics' or Jasper Johns' sketchbook note to 'avoid a polar situation.'

I admire the clarity of Donald Judd's 'Specific Objects' alongside Andy Warhol's philosophy about 'Leftovers.'

I am interested in how Jeff Koons' comments about 'Banality' contrast sharply with the nagging doubt of Gerard Richter's 'Daily Practice of Painting.'

Painting exists in an increasingly sophisticated visual world that has little or no interest in the capability of painting in particular.

Paradoxically, painting can beg, borrow or steal increasingly from the technologies that might be seen to marginalise such a historic, haptic activity.

BIOGRAPHY Richard Kirwan was born in Southampton in 1969. He studied at Winchester School of Art 1987-88, Brighton Polytechnic 1988-91 and Goldsmiths College London 1992-94. His solo exhibitions include *Recent Paintings* Southampton City Art Gallery 2001, *Italian Paintings* British School at Rome 2002, *Modern Blood* Galerie Hollenbach Stuttgart 2004, *Devil's Detail* Hornsey Pump House Gallery London 2005, New Paintings & Works on Paper Ausstellungsraum Zürich 2006 and *Modern Manners* Galerie Hollenbach Stuttgart 2007. Recent group exhibitions include *Abstract Mode* Contemporary Art Projects London 2006 and *Mythomania : Double Use* Nunnery Fine Arts London 2007.

Richard Kirwan

Mie Olise Kjærgaard

Watchtower with Green Stick 2008

Acrylic and polymer on canvas, 190 x 185 cm

I am a painter and sculptor, working with abandoned constructions – architecturally and psychologically. These contrast, question and underline their site specific premises, dealing with an idea of abandoned space and the uncanny. They also evoke ideas of (extremist) sect communities.

My work concentrates on something I call 'porous constructions.' Abandoned empty shells: mines, cargo ships, watchtowers, barns and sheds – left for something else to happen, to mourn or just to keep an open mind about. A mutation; an inhabitation; a penetration; extending themselves in unlikely ways.

As a *painter,* I find scrap photos, mostly places I haven't been to myself, and therefore don't really know. I build and add to machinery-like constructions. The paintings are approached with dogmatic rules about strokes, colours and transparency, rules to bump against and crash. As a *constructor* of huge wooden structures, I first make small scale models and investigate the sites. Each site is different and offers new paradigms. In 2007 I travelled to the Russian abandoned city, The Pyramid, near the Polar Circle and examined the architecture of its society and the mine constructions. This is the basis for my ongoing project about Utopian ideas falling to the ground.

BIOGRAPHY Mie Olise Kjærgaard was born on Mors, Denmark in 1974. She studied at A-Aarch Aarhus DK/ The Bartlett London 1995-2001, Central Saint Martins London (graduated 2007), and undertakes the ISCP New York 2009-10. London group shows include *Celeste Art Prize* 2007 Old Truman Brewery (finalist), *4 New Sensations* (Saatchi Gallery/Channel 4 competition) Old Truman Brewery 2007, *Tipping Point* Purdy Hicks Gallery 2008 and a two-person show (forthcoming) Standpoint Gallery 2008. Solo shows include *Mutated Small Town Limbo* Roskilde Gasworks DK 2007 and *Penetrating Pores of Construction* Barbara Davis Gallery Houston USA 2008.

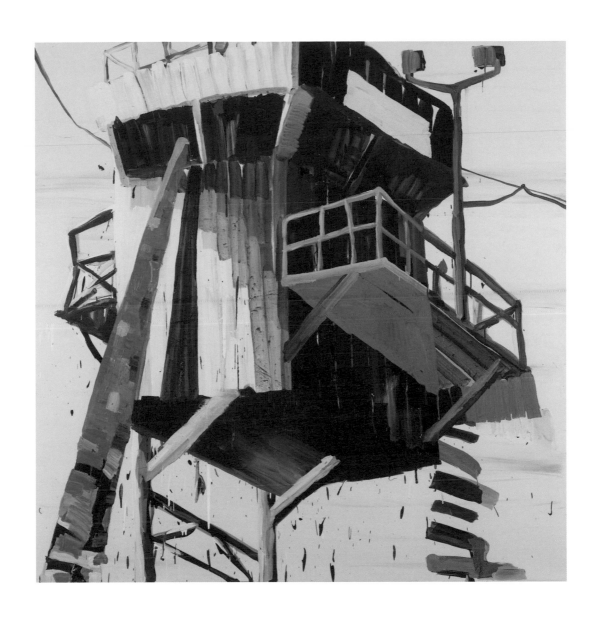

Mie Olise Kjærgaard

Matthew Usmar Lauder

Untitled (Hole) 2007

Oil on canvas, 61 x 45.7 cm

It is the subjective and formative nature of our memory and understanding of the world that interests me. Through my work I aim to create ambiguity and construct a psychological space that requires interpretation.

I start a piece of work with one or more ingredients, a feeling, a thought or a piece of information. This can take the form of a photograph, a film clip or perhaps something I have read or heard. The source image might depict people, an individual or a space devoid of, but still saturated by, human presence.

From there the development process is organic and accumulative. I strip away and discard superfluous detail, with most information becoming purposely muted and/or veiled. I may still retain elements or certain characteristics that attracted me to the material in the first place: flash or low lighting, crude cropping, blurring or even elements of the chemical process of photography itself.

The information behind the image exists layered within the fabric of the painting and is there to be found. If the viewer does not discover the information then he or she will bring their own ideas and insights to the table, based on their personal experiences and perspective. In this respect I see it as a shared continuation of the creative process.

BIOGRAPHY Matthew Usmar Lauder was born in London in 1963. He studied at Camberwell College of Arts London 1982-6. His solo exhibitions include *Matthew Usmar Lauder* Mobile Home Gallery London 2003, *New Works* Fred [London] Ltd and Fred [Leipzig] Ltd 2007, with a further show *Fable* Fred [London] Ltd forthcoming in 2008. He featured in groups exhibitions *Art and Architecture* BA Headquarters London 2003, *BP Portrait Award* 2003 National Portrait Gallery London, *Summer Exhibition* Royal Academy London 2003 and *Traditional But New* Binz And Krämer Gallery Cologne 2007.

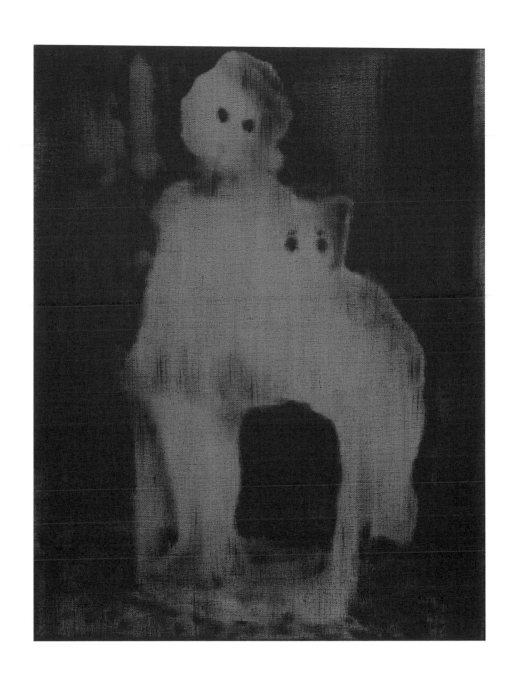

Matthew Usmar Lauder

Geoff Diego Litherland

My Flag is Better than Yours 2008

Oil on linen on board, 100 x 100 cm

Residing in multiple Latin American and European countries raises awareness of the arbitrariness of cultural heritage and identity. Responding to such a nomadic existence with its multifarious ideologies requires an unforgiving medium where the imperfections of reality cannot be glossed over.

The primacy of paint and its ability to create visibly contrasting layers still allows for both a sense of the history of the medium and its genial denial. It is at the point at which the new collides with and intrudes on the old that something is revealed: bright, thickly brushed paint sits roughly atop of darker, scumbled marks, puncturing their pretentions.

I regard everything in this painting as absolutely and unequivocally necessary, especially the sense of conflict.

BIOGRAPHY Geoff Diego Litherland was born in Tehuacan, Mexico in 1979. He studied at Falmouth College of Arts 1999-2002. His group exhibitions include *Drawing Out* Bonington Gallery Nottingham 2008, *Spring Exhibition* J-Gallery Northampton 2008, *Process* Southwell Artspace Nottinghamshire 2006 and *BAC!* Tallers Mina Barcelona 2003. He has had residencies at the Sail Loft St Ives 2001 and Goldfactory Project Space Nottingham 2008. He won the *Grand Jury Prize* for experimental film at Arizona Film Festival 2004. Forthcoming exhibitions include a solo show *Multiverses* at Wallner Gallery Nottingham and a group show *Goldsoundz* Southwell Artspace which he is also curating.

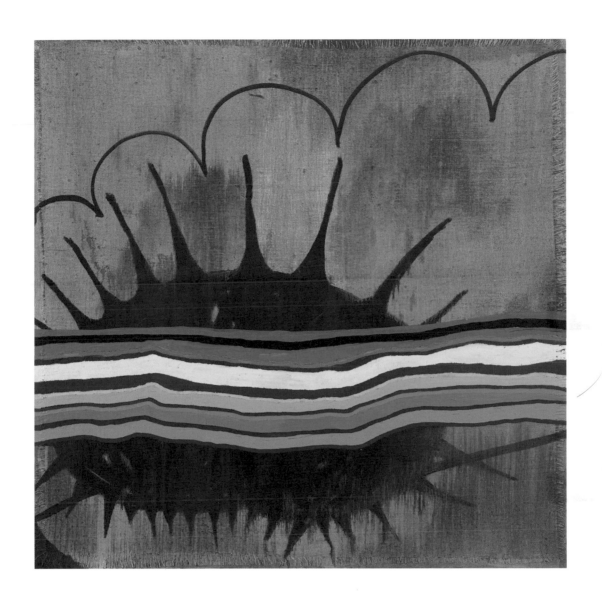

Geoff Diego Litherland

Marta Marcé

Flowing 2 2007

Acrylic on wood, 160 x 122 cm

I am interested in the idea of play as a metaphor for how society operates. We live in an era where daily life is becoming ever more structured, planned and controlled. It feels as if there exists a complex group of games with rules and laws to follow, while at the same time there are rule-breakers and alternatives to the system.

I am exploring how games can function in a similar, parallel way and the relationship of that idea to my work. As well as in painting, games have space and time limitations. Decision-making and chance are also involved. I investigate how these diverse elements can inform my creative production of art.

Rules can provide a basis for painting, issuing instructions and outlining strategies. At the same time, decision-making, chance and judgment allow the breaking of the system, hopefully enjoying fresh and direct creative actions, opening up new possibilities for the outcome.

The use of basic geometric shapes reinforces a universal understanding, while at the same time these are not rigid painted shapes. I also use non-geometric shapes, suggesting more the human activity in the artwork. Colour and its different qualities are an important aspect of my practice. I treat colour as an evolving experimentation within our cultural and visual context.

BIOGRAPHY Marta Marcé was born in Barcelona in 1972. She attended Facultat de Belles Arts Barcelona 1990-95 and the Royal College of Art London 1998-2000. London solo shows include *Diadem Paintings* Riflemaker 2007 and *Is this abstraction?* (residency) Camden Arts Centre 2007. Group shows are *Jerwood Painting Prize 2001* Jerwood Space London, *Marta Marcé: Recent Work* (with Sigmar Polke) Milton Keynes Gallery 2001, *The Bold & the Beautiful: New Art from London* Carnegie Gallery Hobart Australia 2003, *New British Painting: Part I* John Hansard Gallery Southampton 2003, *Slipping Abstraction* Mead Gallery Warwick 2007 and *Displaypark* South London Gallery 2008. Included in *John Moores 23* 2004.

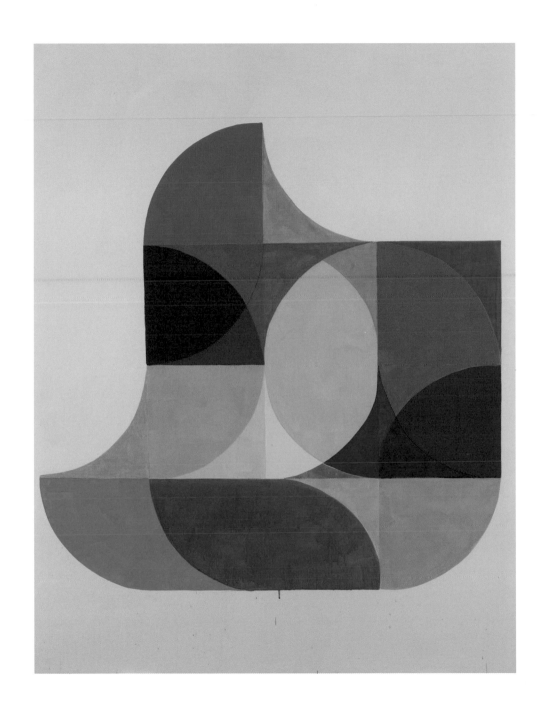

Marta Marcé

Michelle McKeown

Cunt 2008

Oil on paper, 40.5 x 50.7 cm

The butterfly genitalia may give rise to possible notions of Psyche, Freud, Rorschach charts and historical references to the butterfly as symbolic of the soul, rebirth and immortality. However, aware of the process that has brought the work into being, what is more pertinent for me is the conflation of two opposing systems of 19th -century thought, together on one plane - those of Romanticism and Realism.

Inspired by the *'Klecksographien'* of Justinus Kerner (natural philosopher, poet and doctor of the dark-side of nature, 1786-1862), the enactment of an inkblot experiment while referencing Courbet's famous realist nude might present one with, in the words of Enrico Prampolini, ' . . . taking to its extreme the idea of substituting completely and fundamentally the *reality* of paint with the *reality* of matter.'

The simple gesture of the fold reinforces the anthropomorphism of the 'nature' that is depicted, while revealing simultaneously the nature of its production.

BIOGRAPHY Michelle McKeown was born in Northern Ireland in 1979. She studied at the National College of Art and Design Dublin 1998-2001 and the Royal College of Art London 2005-07. Awards include the Basil H Alkazzi Scholarship Award 2005-07. Selected group exhibitions include *Ritual Abuse* The Boy's Hall Dalston London 2007, *The Great Exhibition* Royal College of Art 2007, *Matches and Petrol* A&D Gallery London 2006, *Taster* Hockney Gallery Royal College of Art 2006 and *Contemporary Counterparts* Belltable Arts Centre Limerick 2005. She had a solo show *Strange Attractor* at Loughborough University Gallery 2008. She was artist-in-residence at Loughborough University 2007-08.

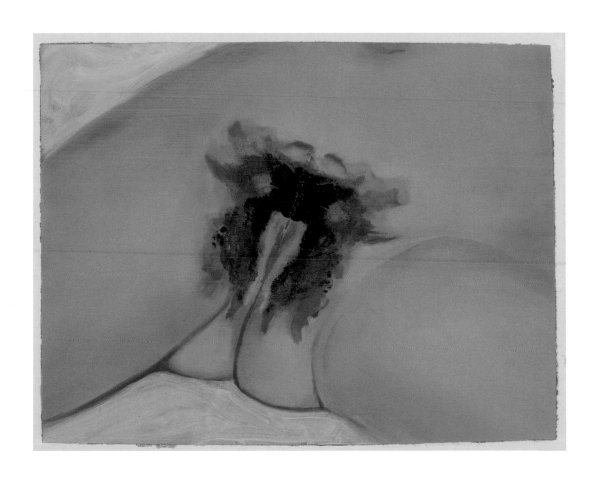

Michelle McKeown

Eleanor Moreton

Prince (tilted) 2008

Oil on canvas, 40 x 30 cm

Much of my recent work has been related to the Romantic, both as a movement and as a more personal manifestation of longing, desire and the imagination. 'The Princes' are part of this body of work, relating to fairytales and our girlish longings for love. Some of them take as the starting point Disney-style princes; others take the romantic hero Cary Grant. But they are always corruptions of their starting points. *Prince (tilted)* is inspired by Slovakian puppets, but also refers to another motif I use, 'The Hapsburg Hat.' This was a felt hat I bought for a partner, which reminded me of hunting hats worn by the Austro-Hungarian Emperor, Franz Josef.

I work with clusters of ideas, often not entirely sure of their inter-relatedness. As I work, I find myself pulled in an out of the process of image making, so that in some paintings I give myself over to the creation of illusion and the process itself is very close, whereas in others, I find myself at a great distance from it, considering every action. This duality of process seems to be integral, both to myself and to my subject and the ambivalence I feel towards it.

BIOGRAPHY Eleanor Moreton was born in London in 1956. She studied at Exeter College of Art 1975-79, UCE Birmingham 1993-96 and Chelsea College of Art and Design 1998-99. Recent exhibitions include *EAST International 2007* Norwich Gallery, *Pranvere* National Gallery of Albania 2007, *The Painting Room* Transition Gallery London 2008 and *These Living Walls of Jet* Ceri Hand Gallery Liverpool 2008. She is Durham Cathedral artist-in-residence 2007-08 and will exhibit at the Reg Vardy Gallery Sunderland 2008 and in *Eleanor Moreton: Cathedral Artist in Residence* DLI Durham 2008 and *Curious and Curiouser* Galleri Rebecca Kormind Copenhagen 2008-09.

Eleanor Moreton

Alex Gene Morrison

Black Bile 2007

Oil and collage (photo inkjet print) on linen, 213.5 x 152.5 cm

Through various media - painting, video/animation and collage - I attempt to explore collisions of meaning, duality within imagery and a sense of the uncanny. The idea of seduction and repulsion is important within the work on both an aesthetic and conceptual level. The flux of multi-layered references flips us from anxiety to ecstasy, to melancholy, to horror. A hypnotic aesthetic binds it all together, in keeping with modern society's increasingly voracious appetite for quick-fix fulfilment. Inevitably we end up narcotized, adrift in the void, stuck in a perpetual loop. However, there is also a sense that through destruction there may be the possibility for renewal, for creation, metamorphosis and therefore evolution. All of this essentially occurs within the same alternate universe. From one work to another there is a potential non-specific narrative link that forms a cast of characters, props and locations.

BIOGRAPHY Alex Gene Morrison was born in Birmingham in 1975. He attended the Royal College of Art London 2000-02. Solo shows include *Vile Lure* Rockwell Gallery London 2006, *Adrift* The Fishmarket Northampton 2007 and *New Dawn* Assembly/Chapter Gallery Cardiff 2008. Group shows include *Fuckin' Brilliant!!* Tokyo Wondersite Japan 2005, *New London Kicks* Wooster Projects New York 2005, *Metropolis Rise: New Art from London* Shanghai/Beijing 2006, *Nature and Society* Dubrovnik Museums Croatia 2007, *Icon* Primo Alonso Gallery London 2008 and *The Past Is History* Changing Role Gallery Naples/Rome 2008. He lectures at City & Guilds of London Art School and was a founding member of Rockwell Gallery and Studios London 2002-07.

Alex Gene Morrison

Kit Poulson

Nought Lovely but the Sky and Stars 2008

Oil, acrylic and tempera on board, 25 x 20 cm

When I was a kid I remember finding a UFO lying on the ground in my neighbour's driveway. Well, when I got real close it turned out to be just some piece of automotive trash. But for a moment I supposed… and I still get that feeling sometimes, reeling under the sweep of the Milky Way. It is a tidal thing, a brief, slight creation that exists only in an uneasy balance of opposing energies. A painting's surface might be thought of in the same way, a site balanced between entropy and some impossible static vitality.

Sputnik: earthbound, or crashed into some other Black Crystal world?

BIOGRAPHY Kit Poulson was born in East Bergholt, Suffolk in 1967. He studied at Edinburgh University (history) 1986-90 and Middlesex University (fine art) 1996-99. Though rooted in painting his practice embraces site specific installation, text, sound and live work. Exhibitions and projects include *The Exhibitionists Festival* (with Alex Baker) ICA London 1998, *I am Empty, I am Full* (solo show) Christchurch Mansion Ipswich 2005, *Stick, Stamp, Fly* Gasworks London (group show) 2007 and *Black Cube/ White Horse* (with Alex Baker) Hartnett Gallery Rochester USA 2008. He has been the *Wheatley Fellow* artist-in-residence at Birmingham Institute of Art and Design since 2007.

Kit Poulson

Sista Pratesi

Black Farm II 2007

Acrylic on canvas with velvet, 91 x 66 cm

Black Farm II is one of a series of paintings that depict a community set in the 1970s. I am inspired by Aldous Huxley's description of a utopian society in his book *'Island'*, and his belief that the key to solving the world's problems lay in changing the individual through mystical enlightenment. My paintings portray a lost society isolated from the outside world. The inhabitants of my invented commune have achieved a form of enlightenment through mental and genetic mutation, as a result of which the power of the individuals and the structure of the society are beyond anything known.

BIOGRAPHY Sista Pratesi was born in Aberdeen in 1966 and lives and works in London. She studied at the Slade School of Fine Art London 1992-94. She won an *Abbey Fellowship* at the British School at Rome in 2002. Her solo shows include *Sista Pratesi* Vexed Generation London 1998, *Black Christmas* Galleria in Arco Turin 2003 and *The Persuaders* Gimpel Fils London 2005. Her group exhibitions include *Twilight* Gimpel Fils London 2003, *Pub Crawl* Gallery 39 London 2004, *Ex Roma* APT Gallery London 2005, *Mirror Mirror* Jerwood Gallery London 2007 and *Weimar Republic* Curtain Road London 2007.

Sista Pratesi

Ged Quinn

There's a House in my Ghost 2008

Oil on linen, 183 x 297 cm

This work quotes from *'Desolation'*, the concluding piece in *'The Course Of Empire'* cycle by Thomas Cole. Its overt visual narrative of a confidently pessimistic version of morality was informed by the historical backdrop of recent epic events. In my painting the scene arrogates markers of cultural and historical identity: a faded 1968 poster of Mao, an old campaigner's tent in an all but abandoned landscape with the remnants of a body spontaneously combusted and a boy asleep on a grave - a symbol from German romantic painting. It develops a coherent and incoherent narrative between disparate periods and symbols, not an identity parade of cultural references that require recognition. Occupation, horror, abandonment spiked with beauty and bathos - the possibility and impossibility of the resolution of everything.

BIOGRAPHY Ged Quinn was born in Liverpool in 1963. He studied at The Ruskin School of Drawing Oxford 1982-85, The Slade School of Fine Art London 1985-87, and the Kunstakademie Dusseldorf 1988-89. Recent group shows include *Wonderings…* The Great Unsigned London 2005, *Salon Nouveau* Engelholm Engelhorn Vienna 2007, *Rockers Island* Olbricht Collection Essen 2007 and *Jekyll Island* Honor Fraser Gallery LA 2008. Recent solo shows are *Utopia Dystopia* Tate St Ives 2004, *The Heavenly Machine* Spike Island Bristol 2005 and *My Great Unhappiness Gives Me a Right to Your Benevolence* Wilkinson London 2007. He features in *Made Up* in the Liverpool Biennial 2008 Tate Liverpool.

Ged Quinn

Neil Rumming

The Baptism 2008

Oil on canvas, 245 × 178.5 cm

I have always been drawn to the abject and absurd reality of modern living. Violence and happiness tucked up in bed together. Cartoons and comedy highlight the ritual humiliation of everyday life. Humour - a defence mechanism when faced with suffering and anguish. I saw a terrible car crash when I was a teenager, people hung upside down, covered in blood. Trying to free these people from the car, I came over all funny. Spontaneous laughter erupted from me, uncontrollable joy anchored in guilt and anxiety. The scene was wild, uncensored, a new territory, and my only response was to laugh.

This exploration of our psychological make-up is something that feeds my work. The invented, animated characters within my paintings are my attempt at examining human behaviour and interaction on a very basic and fundamental level. This is given life by using the biological and industrial landscape that surrounds us. I have always been fascinated with how things work and revealing the mechanistic beings that we all are.

BIOGRAPHY Neil Rumming was born in Frome, Somerset in 1973. He studied at Kingston University London 1992-95. He has exhibited in *Becks Futures 3* ICA London (touring) 2002, *Happy Go Lucky* VHDG Leeuwarden The Netherlands 2004, *Tinta* Eduardo Leme Gallery Sao Paulo Brazil 2006 and *The Souvenir Mine* Mizuma Gallery Tokyo Japan 2006. His solo exhibitions are *Off with their heads!* Habitat Gallery (Kings Road) London 2002 and *Neil Rumming* Karyn Lovegrove Gallery Los Angeles 2003.

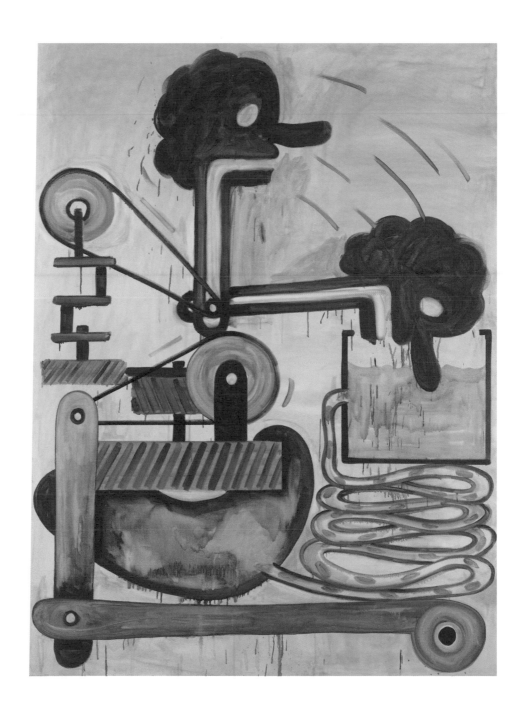

Neil Rumming

Robert Rush

The Dream 2008

Ink and acrylic on paper, 84 x 59 cm

My paintings hang on a nuanced corralling of composition, colour and form. They are arrived at through a process of painting and over-painting, assessing and reassessing arrangements, pushing and pulling, experimenting, but arriving, usually, at a result that looks fresh and immediate. This process is quite fluid. In drawing a line under a shape there is always the possibility that it might expand to become a painted shadow under a form, and that the form may become something else with just a stroke of the brush. The boundaries of painting, drawing and collage are pushed at and negotiated. My practice strives to be constantly reactive and the paintings mutable.

The work invokes sentiments of optimism, happiness and humour on the one hand, yet something altogether more malevolent, manic or hysterical on the other. These sentiments play off allusions to the schematic, organic, figurative and architectural. Elements emerge and dissipate, just as a line becomes a shadow. There are elements of whimsy involved, of visual humour, both light and dark. The works operate in a field of historic references and ideas - both grand and local, held open in their rich, complex and sometimes contradictory fullness.

(From an original text by Alistair Duncan)

BIOGRAPHY Robert Rush was born in Guildford in 1978. He studied at Central Saint Martins London 1999-2001 and the Royal Academy Schools London 2003-06. Recent exhibitions include *Bloomberg New Contemporaries 2006* Club Row Rochelle School London (touring), *Planetarium* APT Gallery London 2008 and the solo shows *Gambit* Lorem Ipsum Gallery London 2008 and *State of Play* Marksman Gallery Reading 2008.

Robert Rush

Michael Stubbs

Virus Maximizer 2008

Tinted floor varnish, eggshell and gloss paint on MDF, 183 × 244.5 cm

Michael Stubbs's paintings use the by-now venerable abstract painting technique of pouring to risk a certain loss of control, and yet by using blown-up stencils to interrupt these random flows with fragments of words, images, or hand-me-down decorative motifs, he constantly keeps a discursive, referential function in play. Or maybe it should be put the other way round: Stubbs's imagery seems constantly on the verge of converging into some form of cultural commentary, but the fundamental abstractness and even irrationality of his overlapping, poured shapes seems calculated to prevent that - to insist on the painting as an agreement to disagree between wayward materials and stubborn intentionality. As Paul Morrison wrote (in *'Contemporary Visual Arts'*) of an earlier phase of Stubbs's work, "the paintings operate as perceptual palimpsests in which the artist overwrites modernist tropes with playful irreverence."

(Text by Barry Schawbsky)

BIOGRAPHY Michael Stubbs was born in West Sussex in 1961. He studied at Bath Academy of Art 1984-87 and Goldsmiths College London 1988-90 and 1999-2003. His group exhibitions include *Painting as a Foreign Language* Centro Britanico Barzsiliero São Paulo 2002, *New Abstract Painting: Painting Abstract Now* Museum Morsbroich Leverkusen Germany 2003 and *Hypersurface Plus* OVADA Oxford 2008. He was a finalist in the *Celeste Art Prize* The Well Truman Brewery London 2006 and was included in *John Moores 24* 2006. His eponymous solo exhibitions include those at Marella Contemporary Art Milan 2005, Hollenbach Gallery Stuttgart 2006 and Baro Cruz Gallery São Paulo Brazil 2007.

Michael Stubbs

Matthew Wood

S-CAT LRAB1 2007

Acrylic and Dulux 'one coat' emulsion on board, 24 x 15.5 cm

I paint on found and fabricated sections of board in one sitting in site specific locations. My work explores the environment, whether constructed or natural. I am interested in a sense of place and atmosphere and the painterly depiction of space and distance, all of which can be associated with both landscape and interior. Until three years ago my work was primarily landscape.

The opportunity to exhibit in a disused office space led me to begin the process of painting in a man-made environment where I generated a mini-series which, as with my approach to landscape, was produced in one sitting using an opaque palette of white emulsion and acrylics. I have since been based in Oriel Davies, domestic Belgian interiors, S-CAT and a disused MOD radio station.

S-CAT LRAB1 is where I teach. It is a Life Room and I have attempted to capture its atmosphere through the sense of composition and harmonious perspective in the painting.

BIOGRAPHY Matthew Wood was born in Morecambe in 1973. He studied at Middlesex University 1995-98 and the University of Wales 2000-01. Having previously been based in Brussels, he is currently based in Wales. Exhibitions with the west Wales artists' group 'Fforma' include those at Y Tabernacl Museum of Modern Art Wales Machynlleth 2003, St. David's Hall Cardiff 2004 and Oriel Plas Glyn-y-Weddw Arts Centre Llanbedrog Pwllheli Gwynedd 2006. He has shown continuously at Kilvert Gallery Clyro Hay-on-Wye 2006-08 and had a recent solo exhibition In Focus Interiors In Focus Oriel Davies Newtown Powys 2007.

Matthew Wood

Stuart Pearson Wright

Woman Surprised by a Werewolf 2008

Oil on linen, 200 × 315 cm

In 2007 I fell in love with a waitress from Aberystwyth. I rented a small cottage there and we explored the surrounding verdant landscape together. The chance discovery of small lambs, which had been slaughtered by birds of prey in implausibly bucolic settings, brought to mind the John Landis film, *'An American Werewolf in London.'* This had scarred my subconscious and stimulated my imagination as a child. I began to consider the indifferent and potentially destructive forces at work in the natural world.

At this time I was experiencing something of a sexual epiphany, coming to terms with my own identity as a sexual animal (the natural world as manifest in my own urges). The symbiosis of wolf and man in the figure of the werewolf came to represent these ideas.

I found myself drawn to the lowbrow associations of the werewolf film sub-genre and was interested to explore that uncharted place where the mystery and sublime of the romantic landscape meets the high camp and melodrama of Hammer horror. *Woman Surprised by a Werewolf* is the first canvas in a proposed four-part narrative.

BIOGRAPHY Stuart Pearson Wright was born in Northampton in 1975. He studied at the Slade School of Fine Art London 1995-99. His group shows include *BP Portrait Award* National Portrait Gallery London 1998, 1999, 2000, 2001 (1st prizewinner), *Jerwood Drawing Prize* Jerwood Space London (touring) 2007 and *Home and Garden* Geffrye Museum London 2008. His most recent solo show was *A Hole in The Bucket* Galerie Huebner Frankfurt 2007. Other prizes include *Garrick/Milne Prize* 2005 and *Singer & Friedlander/Sunday Times Watercolour Competition* 2004. He is represented in several public collections including the British Museum and The Government Art Collection.

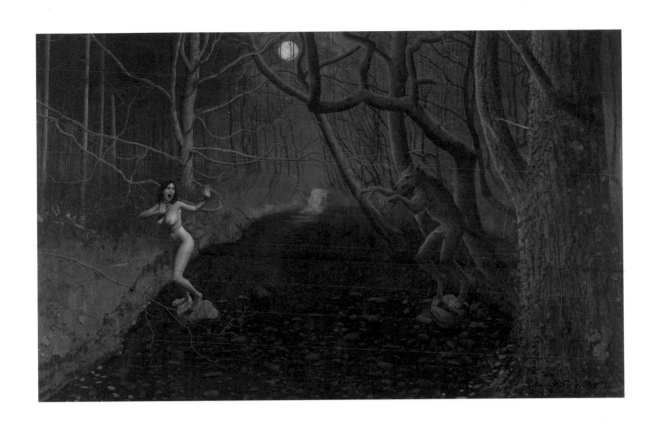

Stuart Pearson Wright

Vicky Wright

Extraction 1 2007

Oil, blackboard paint and plastic tape on panel, 46.7 x 35.7 cm

Extraction 1 forms part of a series of reversed canvases that propose a hidden story, not confined to our past colonial abuses, but to an equally stark future in which Western interests operate covertly to maintain control of vast mineral wealth, obscured by almost complete silence.

Portraiture of the 18th century is seen by many as a golden period within British art; but without the capitalist patrons, arguably such works would not have existed. The human cost of this art seems not to be part of our consciousness. Like an unspeakable truth, or a disgraced family member.

When the Marquis de Sade refers to 'extraction' he does so in terms of 'pimps', or 'libertines', amoral men who "extract their rents at the price of unbearable miseries." These libertines would display their wealth unashamedly, as a symbol of wealth and perceived superiority.

Such vivid depictions of carnal exploitation are examples, to some, of de Sade's amorality, but equally we could see them as a metaphor for that which is concealed within the heart of the mercantile body. Like de Sade's pimps, a portrait may act as a symbol, but its purpose is to act as a mask to obscure the true character of the mercantile body.

BIOGRAPHY Vicky Wright was born in Bolton in 1967. She studied textiles at John Moores University Liverpool 1988-91 and the RCA London 1991-93, and fine art at Goldsmiths College London 2006-08. Group shows include *Temporary Accommodation* Whitechapel Art Gallery London 2001, *Daniel Spoerri's Eat Art* Aktionsforum Munich 2001, *The Full English* MOT London 2003, *Snip Decisions* Chisenhale Gallery London 2003, *Ein Grosser Scwhartzer* Alfred Camp London 2007, *Salon Nouveau* Engholm Engelhorn Galerie Vienna 2007, *Jerwood Painting Prize* 2007 Jerwood Space London, *Latitude* NYCAMS Gallery New York 2008. Solo shows include *Pineal Pastures* IBID Projects Vilnius Lithuania 2004.

Vicky Wright

Index of artists

National Museums Liverpool can not be held responsible for the content of external websites

Georgina Amos
3 Cockcroft Place
Clarkson Road
Cambridge
CB3 0HF
www.georginaamos.co.uk

Tim Bailey
15 Breamore House
Friary Road
London
SE15 1SQ

Richard Baines
28 Ashley Avenue
Lower Weston
Bath
BA1 3DS
www.richardbaines.net

Christopher Barrett
Old Police House
High Street
Lower Brailes
Banbury
OX15 5HW

David Bowe
47 Marcon Court
Amhurst Road
Hackney
London
E8 1LN

Julian Brain
13 Green Park
Green Lane
Hardwicke
Gloucestershire
GL2 4QA

Tom Bull
33 Crabtree Lane
Lancing
West Sussex
BN15 9PP
www.tompbull.com

Louisa Chambers
Flat 3, 102 Cazenove Road
London
N16 6AD
www.louisachambers.com

Clare Chapman
30 White's Square
London
SW4 7JL
www.clarechapman.com

Jake Clark
12 Tasman Road
London
SW9 9LT
www.jake-clark.co.uk

Sam Dargan
49 Rowe House
Chatham Place
Hackney
London
E9 6LX
www.rokebygallery.com

Geraint Evans
5 Robins Court
Birdhurst Road
Croydon
CR2 7EE

Damien Flood
13 Seapoint Court Apartments
Seapoint Road
Bray, Co. Wicklow
Ireland

Grant Foster
Unit 2B
Oslo House, Westwing
20 Felstead Street
Hackney Wick
London
E9 5LT
www.commentart.com/artist/
Grant_Foster

Jaime Gili
Riflemaker Gallery
79 Beak Street, Regent Street
London
W1F 9SU
www.riflemaker.org
www.jaimegili.org

Gabriel Hartley
236A Battersea Park Road
Battersea
London
SW11 4ND
www.gabrielhartley.co.uk

Georgia Hayes
Diamonds
Bells Yew Green
Sussex
TN3 9AX
www.georgiahayes.com

Gerard Hemsworth
Carriage House
2A Tavistock Terrace
London
N19 4DB

Roland Hicks
11 Thorsden Way
London
SE19 1RA
www.rolandhicks.co.uk

Ian Homerston
22 St. James Road
Stratford
London
E15 1RL

Neal Jones
32B Elder Avenue
London
N8 8PS
ww.nealjones.co.uk
www.dearnealjones.co.uk
www.kindlingart.co.uk

Stephanie Kingston
105 Newlands Park
London
SE26 5PW

Richard Kirwan
72 Sandmere Road
Clapham
London
SW4 7QH

Mie Olise Kjærgaard
Alexia Goethe Gallery
7 Dover Street
London
WIS 4LD
www.olise.dk

Matthew Usmar Lauder
101A Westbourne Park Villas
London
W2 5ED
www.matthewusmarlauder.com
www.fred-london.com

Geoff Diego Litherland
10 Monks Lane
Gotham
Nottingham
NG11 0JR
www.geofflitherland.info

Marta Marcé
Riflemaker Gallery
79 Beak Street, Regent Street
London
W1F 9SU
www.martamarce.com

Peter McDonald
c/o Kate MacGarry
7a Vyner Street
London
E2 9DG
www.katemacgarry.com

Michelle McKeown
31 Paget Street
Loughborough
LE11 5DS
www.michelle-mckeown.com

Eleanor Moreton
2 The College
Durham
DH1 3EQ
www.eleanormoreton.co.uk
www.cerihand.co.uk/index.php?/
eleanor-moreton

Alex Gene Morrison
Basement Flat
287 Glyn Road
Hackney
London
E5 0JP
www.re-title.com/artists/AlexGene-
Morrison.asp

Kit Poulson
185 Grange Road
London
SE1 3AA
www.kitpoulson.com

Sista Pratesi
47 King Henry's Road
London
NW3 3QR
www.gimpelfils.com

Ged Quinn
Trenant Farm
Great Bosullow
Mardom
Cornwall
TR20 8NP
www.wilkinsongallery.com/ex07_
gedquinn.php>

Neil Rumming
20A Tyrwhitt Road
Brockley
London
SE4 1QG
www.neilrumming.com

Robert Rush
Postford House
172 Dorking Road
Chilworth
Surrey
GU4 8RN
www.loremipsumgallery.com

Michael Stubbs
16 Wrexham Road
Bow
London
E3 2TJ
www.michaelstubbs.org

Matthew Wood
41 Pentre Gwyn
Trewern
Welshpool
Powys
SY21 8DZ
www.matthewwoodpaintings.co.uk

Stuart Pearson Wright
621A Roman Road
London
E3 2RN
www.stuartpearsonwright.com

Vicky Wright
165 Holland Park Avenue
London
W11 4UR
www.old.gold.ac.uk/art/exhibitions/
mfa2008/pages/vw/01.html

John Moores exhibition fact file 1957-2008

On 7 August 1957, Littlewoods's founder John Moores wrote this letter to the Editor of the *Sunday Times:*

"Living in the provinces as I do, I am one of those deeply concerned with the plight of provincial museums and art galleries. But I have often thought that decline has something to do with the concentration of art shows, art criticisms and the like in London.

Surely, to be a living thing a provincial gallery must play a real part in the cultural life of the town it serves, and not merely be a pale and distant reflection of what is going on in the metropolis.

It is because I believe this that I am collaborating with the Walker Art Gallery, here in Liverpool, to organise an art exhibition open to any artist working in Britain, coupled with the offer of substantial prizes.

When leading artists exhibit this Autumn at the Walker Art Gallery – the exhibition opens on November 9 – the Gallery will be serving the very purpose for which it was designed, and act as a focus for cultural life on Merseyside.

What we are planning in Liverpool can be planned elsewhere. It is far better, in my view, for provincial galleries to seek and gain support from local patrons, then [sic] to receive a grant of money from the government. Anonymous subsidies are not the way to generate, locally, the 'climate of discernment' of which your art critic wrote so sensibly last week."

The first John Moores Liverpool Exhibition was held at the Walker Art Gallery 10 November 1957- 11 January 1958.
The exhibition's aims, stated in the first catalogue, were:
1 To give Merseyside the chance to see an exhibition of painting and sculpture embracing the best and most vital work being done today throughout the country;
2 To encourage contemporary artists, particularly the young and progressive.

The following is a summary of information drawn mainly from the published catalogues of the exhibitions from 1957-2008. It includes the names of selectors and prizewinners, reveals the frequent changes to entry criteria and categories and offers additional facts chronicling the history of the 'John Moores.' (The latter title is used for brevity.)

The 'Purchase prizes', which come and go throughout the history of the John Moores, are complex in their nature and administration. In their most simplified form, in addition to the artist winning the prize money, the winning work became the property of John Moores. On several occasions, but not always, these works were then gifted by him (and later the John Moores Exhibition Trust) to the Walker Art Gallery. The Gallery also made numerous separate acquisitions from the exhibitions. A full list of works acquired by the Walker through these various means can be found on page 138.

The conditions of entry throughout state that works must be by living artists. Number of works entered into each exhibition is included where known.

John Moores 1, 1957

- Exhibition launches to widespread press coverage
- The three categories comprise an Open section, Junior section and Invited artists
- Invited artists included Ceri Richards, L. S. Lowry, Joseph Herman, Reg Butler
- A Purchase prize is created
- Jack Smith becomes the exhibition's first winner with 'Creation and Crucifixion'

Selected by:
Professor Lawrence Gowing, CBE
Eric Newton
Sir John Rothenstein, CBE
Hugh Scrutton
John Berger was prevented from taking part in judging owing to illness.

Conditions of entry: Oil and tempera paintings and sculpture by artists working in the UK, each of whom could submit two works.
Invited artists' section ('distinguished artists' could send in two works; not subject to Selection Committee, but still eligible for prizes)

Number of entries	2,059
Number of exhibits	181

Prizewinners:

Open section (3 Purchase prizes):
Jack Smith 1st prize £1,000
Ceri Richards 2nd prize £750
Victor Pasmore 3rd prize £500
5 prizes of £100:
Ralph Brown
Cecil Collins
Josef Herman
Uli Nimptsch
Sir Matthew Smith
2 special prizes £75:
Derrick Greaves
Philip Sutton
Junior section (artists up to 36 years old on 9 Nov 1957) (3 Purchase prizes):
John Bratby 1st prize £500
Sheila Fell 2nd prize £250
Terry G. Lee 3rd prize £100
10 prizes of £25:
Roy C. Cross
Margaret E. Evans
Anthony Fry
George Fullard
James Howie
Ralph B. Shaberman
Jack Simcock
F. N. Souza
Ian Stephenson
Joseph C. Tilson

John Moores 2, 1959

- Introduction of a French section for artists from the 'Ecole de Paris'
- Introduction of a separate prize for British sculpture
- Abolition of the Junior section: "Younger artists stood in no need of protection from the competition of their elders."
- Two juries instead of one (the second, selecting the main prize, comprised of Prof G. C. Argan, Professor of Art History, University of Rome; Prof A.M.W.H. Hammacher, Director, Rijksmuseum Kröller-Müller, Otterlo; Prof Kurt Martin, Director General, Bayerisches Staatsgemäldesammlungen, Munich). Their selection was made from 'the best' 25 British paintings (inc prizewinners) selected by the main jury and the submitted French paintings, but excluding the 'Hors concours'.
- Purchase prizes abolished and £1,000 set aside for purchase as distinct from prizes
- Invited artists included William Scott, Carel Weight, Anne Redpath; Hors concours included Barbara Hepworth and Henry Moore

Selected by:
Eric Newton (Chair)
Alan Bowness
André Chastel
Hugh Scrutton
Gabriel White

Conditions of entry: British artists: oil and tempera paintings and sculpture; each artist could submit one work, preferably new.
French artists: no sculpture; otherwise as British, plus size restriction for transport.
Invited artists' section (not subject to Selection Committee, but still eligible for prizes)
'Hors concours' section (invited but neither subject to Selection Committee, nor eligible for prizes): "Artists whose distinction is such that they may be said to be above the battle."

Number of entries 1,807
Number of exhibits 157

Prizewinners:
Main prize:
Patrick Heron £1,000
British painters' section:
William Scott 1st prize £500
Peter Lanyon 2nd prize £400
Robin Philipson and Ceri Richards 3rd prize £300
Prizes of £100:
Roger Hilton
Anne Redpath
British sculptors' section:
Hubert Dalwood 1st prize £500
Ralph Brown 2nd prize £250
French Painters' Section:
Paul Rebeyrolle 1st prize £500
François Arnal 2nd prize £250

John Moores 3, 1961

- Invited artists and French sections abolished
- Junior section reinstated, for artists under 36 years old
- Organisers guarantee to purchase works to a total value of at least £750
- Maximum size imposed of 10' high × 7' wide
- Mundy's winning painting is purchased by the Friends of Bristol Art Gallery for the gallery's collection

Selected by:
John Moores (Chair)
Alan Clutton-Brock
Robert Medley
Robert Melville
John Russell

Conditions of entry: British artists: oil and tempera etc. paintings or sculpture; each artist could submit one work, preferably new.
'Hors concours' section (invited but neither subject to Selection Committee, nor eligible for prizes)

| Number of entries | 2,083 |
| Number of exhibits | 132 |

Prizewinners:
Open section (paintings):
Henry Mundy 1st prize £1,000
Sandra Blow 2nd prize £500
Leon Kossoff 3rd prize £300
R. B. Kitaj 4th prize £100
Junior section (paintings):
Peter Blake 1st prize £250
Euan Uglow 2nd prize £100
Five prizes of £50:
Anne Bruce
Anthea Alley
Hussein Shariffe
Dennis Creffield
David Hockney
Open sculpture prizes:
Evelyn Williams 1st prize £500
F. E. Mc William 2nd prize £250

John Moores 4, 1963

- Value of prizes increased
- Sculpture section abolished
- Junior section: eligible age reduced to 'not exceeding 25 years old on 12 Nov 1963'
- Invited artists' section reintroduced and included in prize competition
- Purchase prizes reintroduced
- Oskar Kokoschka exhibited under '*Hors concours*' section: "It is a great pleasure to have a painting by the greatest living British artist."
- Artists including Adrian Henri exhibit works not accepted for the John Moores at Liverpool's Everyman Cinema, with a reception hosted by 'Miss Refuse 1963.'

Selected by:
John Moores (Chair)
Ronald Alley
Sir William Coldstream
Peter Lanyon
Hugh Scrutton

Conditions of entry: Artists working in the UK; oil, tempera, emulsion or other accepted modern techniques. No sculpture. Each artist could submit one work, preferably new.
'Hors concours' section (invited but not eligible for prizes)

Number of entries	2,421
Number of exhibits	118

Prizewinners:
Open section:
Purchase prizes -
Roger Hilton 1st prize £1,500
Anthony Donaldson 2nd prize £750
Philip Sutton 3rd prize £500
Non-Purchase prizes –
5 prizes of £100
Harold Cohen
Michael Kidner
R.B. Kitaj
Terry G. Lee
Bridget Riley
Junior section:
Purchase prizes –
Stephen McKenna 1st prize £500
Christopher Paice 2nd prize £250
Honourable Mention:
John Bowstead
Michael J. Davidson
Tess Jaray

John Moores 5, 1965

- Jury reduced from three to five people
- First foreign Jury Chair – renowned American critic Clement Greenberg
- Value of prizes increased
- Invited artists included Sidney Nolan, Harry Thubron and Richard Hamilton; 'Hors concours' included Francis Bacon and Ivon Hitchens
- In a UK 'first' for a contemporary art exhibition, the John Moores offers a full guided sound tour and commentary, with a welcome message from John Moores, played on 'individual tape play-back machines'

Selected by:
Clement Greenberg (Chair)
Patrick Heron
John Russell

Conditions of entry: Artists working in the UK; oil, emulsion or other accepted modern techniques. No sculpture. Each artist could submit one work, preferably new.
Invited artists' section (eligible for prizes)
'Hors concours' section (invited but not eligible for prizes)

Number of entries	2,268
Number of exhibits	113

Prizewinners:
Open section:
Purchase prizes -
Michael Tyzack 1st prize £1,500
Michael Kidner 2nd prize £1,000
John Walker 3rd prize £500
Non-Purchase prizes –
5 prizes of £100
Robyn Denny
John Edkins
Terry Frost
John Hoyland
Derek Southall
Junior section:
Tim Whitmore 1st prize £200
8 prizes of £50:
Eleanor Brady
Stephen Marriott
George Moore
Christopher Paice
Geoff Rigden
Ron Robertson-Swann
Peter Wilson
Brian Woollard

John Moores 6, 1967

- The division into Open and Junior sections is eliminated
- David Hockney wins and uses the prize money to send his parents on holiday to Australia

Selected by:
John Moores (Chair)
Adrian Heath
Norbert Lynton
Pierre Restany
Lilian Somerville

Conditions of entry: Artists working in the UK; oil, emulsion or other accepted modern techniques. No sculpture. Each artist could submit one work, preferably new.
'Hors concours' section (invited but not eligible for prizes)

Number of entries	1,813
Number of exhibits	106

Prizewinners:
Purchase prizes:
David Hockney 1st prize £1,500
Malcolm Hughes 2nd prize £1,000
Joe Tilson 3rd prize £750
Non-Purchase prizes –
5 prizes of £100:
Harry Ball
D. A. Cordery
Alan Gouk
Derek Southall
Richard Ward
5 prizes of £50:
Keith Brocklehurst
Douglas Kemp
Gordon Snee
Jean Spencer
Stephen Young

John Moores 7, 1969

- First prize awarded jointly to two separate artists, Mary Martin and Richard Hamilton
- Mary Martin dies suddenly at the same time the Jury are deliberating the awards
- Total prize money raised from £4,000 to £6,500
- No purchase prizes or invited artists
- Introduction of a new rule stating entries must be designed to hang on a wall and project no more than six inches from it. Gallery Director Hugh Scrutton comments, "Nobody can say this has any spiritual significance" and describes the six inches as an arbitrary figure.

Selected by:
Hugh Scrutton
Robyn Denny
Anthony Hill
Howard Hodgkin
R. B. Kitaj
William Scott
Adrian Henri was unable to attend judging.

Conditions of entry: Artists working in the UK; oil, emulsion or other accepted modern techniques, designed to hang on a wall and not project more than six inches. Each artist could submit one work, preferably new. Sculpture, kinetics, watercolours and graphic arts excluded.

Number of entries	1,900
Number of exhibits	91

Prizewinners:
Main prize:
Richard Hamilton and Mary Martin Joint winners, each £2,500
5 prizes of £300:
Rasheed Araeen
Peter Kinley
Robert Owen
Tom Phillips
David Troostwyk

John Moores 8, 1972

- No purchase prizes
- The University of Liverpool purchases Euan Uglow's prizewinning painting for its art collection

Selected by:
John Moores (Chair)
Jasia Reichardt
Tom Phillips
Edward Lucie-Smith

Conditions of entry: Artists working in the UK; oil, emulsion or other accepted modern techniques, designed to hang on a wall and not project more than six inches. Each artist could submit one work, preferably new. Sculpture, kinetics, watercolours and graphic arts excluded.

Number of exhibits 80

Prizewinners:
Euan Uglow 1st prize £3,000
Adrian Henri 2nd prize £2,000
Noel Forster 3rd prize £1,000
5 prizes of £100:
Rita Donagh
Stephen Collingbourne
Terry Setch
Sean Scully
Anthony Eyton

John Moores 9, 1974

- A fourth prize specially added for Sean Scully's *'Subtraction Painting'*

Selected by:
John Moores (Chair)
Susan Grayson
William Feaver
Patrick George

Conditions of entry: Artists working in the UK; oil, emulsion or other accepted modern techniques, designed to hang on a wall and not project more than six inches. Each artist could submit one work, preferably new. Sculpture, kinetics, watercolours and graphic arts excluded.

Number of exhibits 90

Prizewinners:
Myles Murphy 1st prize £3,000
John G. Walker 2nd prize £2,000
Craigie Aitchison 3rd prize £1,000
Sean Scully 4th prize £500
10 prizes of £100:
Michael J. Bennett
Stephen Buckley
Jeffery B. Camp
Maurice Cockrill
Barrie Cook
Anthony Green
Peter Hedegaard
Richard Kidd
Alan Miller
Laetitia Yhap

John Moores 10, 1976

• No purchase prizes

Selected by:
Timothy Stevens (Chair)
Dore Ashton
Peter de Francia
J. Kasmin
Leslie Waddington was unable to attend judging

Conditions of entry: Artists working in the UK; oil, emulsion or other accepted modern techniques, designed to hang on a wall and not project more than six inches. Each artist could submit one work, preferably new. Sculpture, kinetics, watercolours and graphic arts excluded.

Number of exhibits 79

Prizewinners:
John Walker 1st prize £4,000
Howard Hodgkin 2nd prize £3,000
Laurie Baldwyn 3rd prize £2,000
10 prizes of £100:
Stephen Farthing
Chris Hugh Fisher
John Mark France
Dick French
Michael Heindorff
Derek Christopher Johnson
Edwina Leapman
Helen Cecilia Lee
Fernando Maza
Alan Miller

John Moores 11, 1978

• 21st birthday of the exhibition
• Past prizewinners invited to show a work *'hors concours'*
• Purchase prize reinstated
• Free bus service for schools instigated to improve access to the exhibition

Selected by:
Peter Moores (Chair)
Bernard Cohen
Jeremy Rees
Anne Seymour

Conditions of entry: Artists working in the UK; oil, emulsion or other accepted modern techniques, designed to hang on a wall and not project more than six inches. Each artist could submit one work, preferably new. Sculpture, kinetics, watercolours and graphic arts excluded.

Number of entries over 2,200
Number of exhibits 86

Prizewinners:
Noel Forster 1st prize (Purchase prize) £6,000
William Turnbull 2nd prize £3,000
Robyn Denny 3rd prize £2,000
10 prizes of £100:
Gillian Ayres
Michael Brick
Ken Howard
Peter Joseph
Christopher Mark Le Brun
Clement McAleer
Martin Naylor
Brendan Neiland
Andrew Mansfield Ratcliffe
Karl Martin Weschke

John Moores 12, 1980

- Purchase prize retained
- John Moores receives a Knighthood, becoming Sir John Moores

Selected by:
Sir John Moores (Chair)
Patrick Caulfield
Nigel Greenwood
Sir Norman Reid
Ian Stephenson

Conditions of entry: Artists working in the UK; oil, emulsion or other accepted modern techniques, designed to hang on a wall and not project more than six inches. Each artist could submit one work, preferably new. Sculpture, kinetics, watercolours and graphic arts excluded.

Number of entries over 2,000
Number of exhibits 91

Prizewinners:
Michael Moon 1st prize (Purchase prize) £6,000
Howard Hodgkin 2nd prize £3,000
Christopher Le Brun 3rd prize £2,000
10 prizes of £250:
Mark Ainsworth
John Armstrong
John Bellany
Adrian Berg
Stephen Farthing
Timothy Martin Jones
Robert Patrick Burkall Marsh
Mary Potter
Kevin Fergus Sinnott
Trevor Sutton

John Moores 13, 1982

- Purchase prize retained
- Sir John Moores refers to the "unhappy events in Toxteth as well as to economic problems now faced by this part of the North West" in the catalogue preface

Selected by:
Sir John Moores (Chair)
Stephen Buckley
Myles Murphy
William Packer
Joe Tilson, who was to have been one of the judges, was unable to take part

Conditions of entry: Artists working in the UK; oil, emulsion or other accepted modern techniques, designed to hang on a wall and not project more than six inches. Each artist could submit one work, preferably new. Sculpture, kinetics, watercolours and graphic arts excluded.

Number of entries over 2,000
Number of exhibits 76

Prizewinners:
John Hoyland 1st prize (Purchase prize) £6,000
Gillian Ayres 2nd prize £3,000
Adrian Berg 3rd prize £2,000
10 prizes of £250:
Barrie Cook
Joan Dawson
Stephen Farthing
Albert Irvin
John Lessore
Michael Scott
Norman Stevens
Leon Vilaincour
Anthony Whishaw
Emrys Williams

John Moores 14, 1985

- Exhibition rescheduled from 1984 to 1985 owing to gallery roof repairs
- Artists' statements and biographies become a major component of the catalogue, which is also fully illustrated for the first time
- Purchase prize retained

Selected by:
Sir John Moores (Chair)
Michael Craig-Martin
Christopher Le Brun
John McEwen
Nicholas Serota

Conditions of entry: Artists working in the UK; oil, emulsion or other accepted modern techniques, designed to hang on a wall and not project more than six inches. Each artist could submit one work, preferably new. Sculpture, kinetics, watercolours and graphic arts excluded.

Number of exhibits 52

Prizewinners:
Bruce McLean 1st prize (Purchase prize) £11,000
Stephen Buckley 2nd prize £3,000
Terry Setch 3rd prize £2,000
10 prizes of £250:
Allan Boston
Gerard de Thame
Ansel Krut
Simon Lewty
Lisa Milroy
Thérèse Oulton
Adrian Searle
Jack Shotbolt
Andrew Stahl
Christopher Stevens

John Moores 15, 1987

- Purchase prize retained

Selected by:
Sir John Moores (Chair)
Peter Kinley
Ian McKeever
Marco Livingstone
Melina Kalinowska, who was to have been one of the judges, was unable to take part

Conditions of entry: Artists working in the UK; oil, emulsion or other accepted modern techniques, designed to hang on a wall and not project more than six inches. Each artist could submit one work, preferably new. Sculpture, kinetics, watercolours and graphic arts excluded.

Number of exhibits 70

Prizewinners:
Tim Head 1st prize (Purchase prize) £11,000
Joint 2nd prize £4,000 each:
Graham Crowley and Kate Whiteford
10 prizes of £300:
John Bicknell
J. N. Blank
Brian Chalkley
Rodney Dickson
Dick French
William Harvey
Christine Kowal Post
Daniel Mafé
Shanti Panchal
Terry Shave

John Moores 16, 1989

- Purchase prize retained

Selected by:
Tim Hilton
Therese Oulton
Barbara Toll
Kate Whiteford

Conditions of entry: Artists working in the UK;
one painting, preferably new, in an accepted
modern medium, designed to hang on a wall
and projecting no more than six inches.
Sculpture, traditional watercolours and graphics
excluded.

Number of entries 1,938
Number of exhibits 55

Prizewinners:
Lisa Milroy 1st prize (Purchase prize) £14,000
Basil Beattie 2nd prize £4,000
Suzanne Treister 3rd prize £2,000
10 prizes of £500:
Edward Allington
Sue Arrowsmith
Michael Bennett
Dan Gardiner
Martin Huxter
Rosa Lee
Sara Rossberg
Ray Smith
Amikam Toren
Frederick Yocum

John Moores 17, 1991

- Purchase prize retained
- First catalogue to carry colour images of
 all works

Selected by:
Lewis Biggs
Maurice Cockrill
John Hoyland
Jayne Purdy

Conditions of entry: Artists working in the UK;
one painting, preferably new, in an accepted
modern medium, designed to hang on a wall
and projecting no more than six inches.
Sculpture, traditional watercolours and graphics
excluded.

Number of entries 2,018
Number of exhibits 53

Prizewinners:
Andrzej Jackowski 1st prize (Purchase prize)
£20,000
10 prizes of £1,000:
James Brook
John Capstack
Jeff Dellow
Arturo Di Stefano
Stephen Farthing
Nichollas Hamper
Andrea Lansley
Adam Lowe
Jock McFadyen
Michael Simpson

John Moores 18, 1993

- Sir John Moores dies on September 25 1993 and a memorial service is held at Liverpool Cathedral on November 30 1993
- Purchase prize retained

Selected by:
Andrew Brighton
Stephen Farthing
Paul Huxley
Catherine Lampert
Julian Treuherz

Conditions of entry: Artists working in the UK; one painting, preferably new, in an accepted modern medium, designed to hang on a wall and projecting no more than six inches. Sculpture, traditional watercolours and graphics excluded.

Number of entries 2,013
Number of exhibits 54

Prizewinners:

Peter Doig 1st prize (Purchase prize) £20,000
10 prizes of £1000:
George Blacklock
Simon Callery
John Goto
Martin Grover
Alexander Guy
David Howell
Vanessa Jackson
Paula MacArthur
Johannes Phokela
Jose Luis Vargas

John Moores 19, 1995

- The exhibition continues with the support of the Moores family through the John Moores Liverpool Exhibition Trust
- Purchase prize retained

Selected by:
Basil Beattie
Timothy Hyman
Alex Kidson
Frances Spalding

Conditions of entry: Artists working in the UK; one painting, preferably new, in an accepted modern medium, designed to hang on a wall and projecting no more than six inches. Sculpture, traditional watercolours and graphics excluded.

Number of entries 1,644
Number of exhibits 60

Prizewinners:

David Leapman 1st prize (Purchase prize) £20,000
10 prizes of £1000:
Peter Darach
Jeff Gibbons
Paul Green
Jane Harris
Joanna Hyslop
Lucy Jones
Henry Kondracki
Mary Mabbutt
James Rielly
Jane Walker

John Moores 20, 1997

- Celebrated 40 years of the exhibition and the Moores family's support
- 'The Letter', Adrian Henri's poem about 40 years' worth of selection decision envelopes arriving, was published in the catalogue
- Purchase prize retained

Selected by:
Louisa Buck
Mel Gooding
Declan McGonagle
George Melly
Cornelia Parker

Conditions of entry: Artists living or based in the UK; one work definable as a painting (as distinct from a watercolour, drawing, sculpture or other construction); designed to hang on a wall and projecting no more than six inches; additional height and width restrictions.

Number of entries	1,788
Number of exhibits	48

Prizewinners:

Dan Hays 1st prize (Purchase prize) £20,000
10 prizes of £1000:
Sue Arrowsmith
Tony Bevan
Jason Brooks
Gwen Hardie
Claude Heath
Stephen Hughes
Gary Hume
Callum Innes
Masakatsu Kondo
David Leapman

John Moores 21, 1999

- First prize increased to £25,000
- Purchase prize retained
- The John Moores becomes part of the Liverpool Biennial of Contemporary Art

Selected by:
Richard Cork
Mark Francis
Germaine Greer
Dan Hays
Elizabeth A. Macgregor

Conditions of entry: Artists living or based in the UK; one work, new or recent, in a contemporary idiom, wholly or partly in any painted medium and designed to hang on a wall; additional height and width restrictions.

Number of entries	2,100
Number of exhibits	50

Prizewinners:

Michael Raedecker 1st prize £25,000
10 prizes of £1000:
Alan Brooks
Gang Chen
Christopher Cook
Ian Davenport
Angela De La Cruz
Kaye Donachie
Stephen Farthing
Jason Martin
George Shaw
Amikam Toren

John Moores 22, 2002

- Number of prize winners changed to five
- Purchase prize retained
- Entries judged by slide submission for first stage selection and by the actual paintings at second stage
- Visitors' Choice Vote introduced, awarded towards the end of the exhibition
- No printed catalogue – online catalogue only

Selected by:
Matthew Collings
Fiona Rae
Jenny Saville

Conditions of entry: Artists living or based in the UK; one work, new or recent (preferably executed since JM21), wholly or partly in any painted medium; designed to hang on a wall and projecting no more than 0.5m; additional height and width restrictions.

Number of entries 1,400
Number of exhibits 38

Prizewinners:
Peter Davies 1st prize £25,000
4 prizes of £2,500:
Bank
Alan Gouk
Martin Maloney
Paul Morrison

Visitors' Choice winner (no prize money):
Sean Dawson

John Moores 23, 2004

- Entries judged by slide submission for first stage selection and by the actual paintings at second stage
- Printed catalogue reinstated and online catalogue retained
- Purchase prize abandoned in favour of the Walker Art Gallery having the option to purchase the prizewinning painting

Selected by:
Ann Bukantas
Jarvis Cocker
Gill Hedley
Callum Innes
Gavin Turk

Conditions of entry: Artists living or based in the UK; one work, new or recent (preferably executed since JM22), wholly or partly in any painted medium; designed to hang on a wall and projecting no more than 0.5m; additional height and width restrictions.

Number of entries 1,906
Number of exhibits 56

Prizewinners:
Alexis Harding 1st prize £25,000
4 prizes of £2,500:
Andrew Grassie (special merit)
Dougal McKenzie
Sarah Pickstone
Alex Pollard

Visitors' Choice prize £1,000:
Dominic Shepherd

John Moores 24, 2006

- No purchase prize, but 1st prizewinner purchased for the Gallery's collection

Selected by:
Sir Peter Blake
Jason Brooks
Ann Bukantas
Tracey Emin
Andrea Rose

Conditions of entry: Artists living or based in the UK; one work, new or recent (preferably executed since JM23), wholly or partly in any painted medium; designed to hang on a wall and projecting no more than 0.5m; additional height and width restrictions.

Number of entries 2,640
Number of exhibits 52

Prizewinners:
Martin Greenland 1st prize £25,000
4 prizes of £2,500:
Matthew Burrows
Graham Crowley
Vincent Hawkins
James White

Visitors' Choice prize £1,000:
Nicholas Middleton

John Moores 25, 2008

- No purchase prize, but 1st prizewinner purchased for the Gallery's collection
- Celebrating 50 years of the exhibition it is retitled 'The John Moores 25 contemporary painting prize'
- Visitors' Choice prize raised to £2,008 to mark European Capital of Culture year

Selected by:
Jake and Dinos Chapman
Sacha Craddock
Graham Crowley
Paul Morrison

Conditions of entry: Artists living or based in the UK; one work, new or recent (preferably executed since JM24), wholly or partly in any painted medium; designed to hang on a wall and projecting no more than 0.5m; additional height and width restrictions.

Number of entries 3,322
Number of exhibits 40

Prizewinners:
Peter McDonald 1st prize £25,000
4 prizes of £2,500:
Julian Brain
Geraint Evans
Grant Foster
Neal Jones

Visitors' Choice prize £2,008:
To be announced

Previous main prizewinners

(Unless otherwise stated, these works are now part of the Walker Art Gallery's collection)

Illustrated pages 128 - 135

1957	Jack Smith	Creation and Crucifixion
1959	Patrick Heron	Black Painting, Red, Brown and Olive, 1959
		location unknown
1961	Henry Mundy	Cluster
		Bristol Museum & Art Gallery
1963	Roger Hilton	March 1963
1965	Michael Tyzack	Alesso B
1967	David Hockney	Peter Getting Out of Nick's Pool
1969	Mary Martin (joint)	Cross
1969	Richard Hamilton (joint)	Toaster
		location unknown
1972	Euan Uglow	Nude, 12 regular vertical positions from the eye
		University of Liverpool Art Collection
1974	Myles Murphy	Figure Against a Yellow Foreground
		location unknown
1976	John Walker	"Juggernaut with Plume - for P. Neruda"
		location unknown
1978	Noel Forster	A Painting in Six Stages with a Blue Triangle
1980	Michael Moon	Box Room
1982	John Hoyland	Broken Bride
1985	Bruce McLean	Oriental Garden
1987	Tim Head	Cow Mutations
1989	Lisa Milroy	Handles
1991	Andrzej Jackowski	Beekeeper's Son
1993	Peter Doig	Blotter
1995	David Leapman	Double Tongued Knowability
1997	Dan Hays	Harmony in Green
1999	Michael Raedecker	Mirage
2002	Peter Davies	Super Star Fucker
2004	Alexis Harding	Slump/Fear (orange/black)
2006	Martin Greenland	Before Vermeer's Clouds

1957

1961

1959

1963

1965

1969

1967

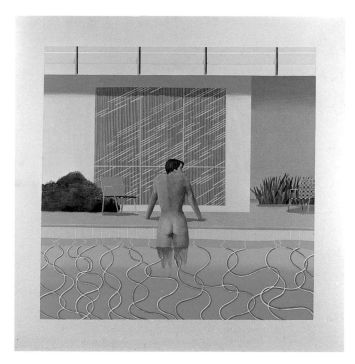

1969

1972

1974

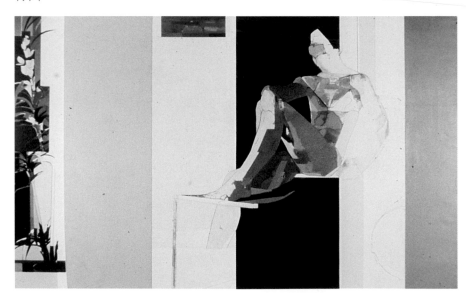

1976

1978

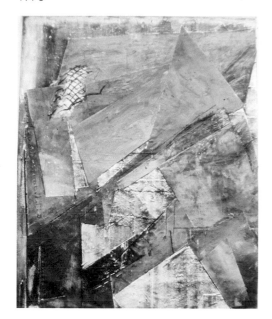

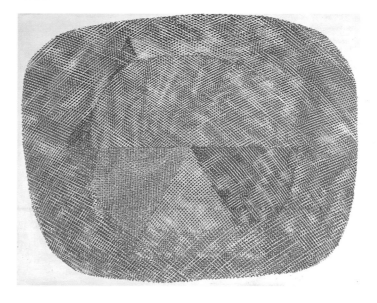

1980

131

1982

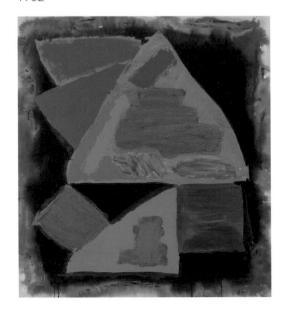

1987

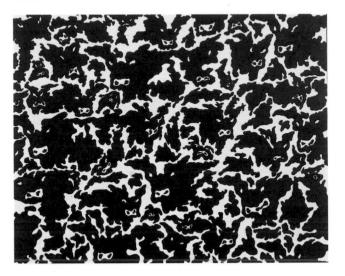

1985

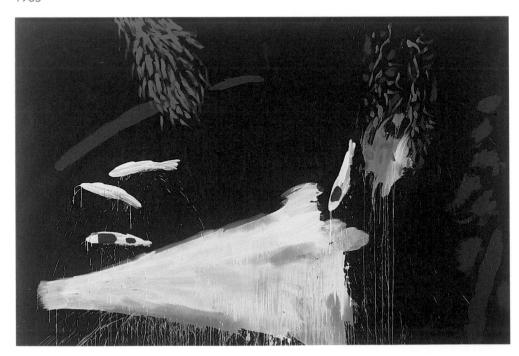

1989

1993

1991

1995

1997

1999

2002

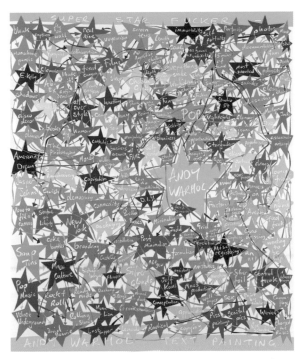

2004

2006

135

Additional Walker Art Gallery acquisitions

Additional works previously exhibited in the John Moores exhibitions and
acquired for the Walker Art Gallery's collection

1957	John Bratby	Three Self-Portraits with a White Wall
1957	Margaret Evans	Blue Still Life
1957	Sheila Fell	Houses near Number Five Pit
1957	Terry Lee	Bathroom, Regent's Park
1957	Victor Pasmore	Abstract in Black, White, Maroon and Ochre
1957	Robin Philipson	Edinburgh in Summer
1957	Ceri Richards	Trafalgar Square II
1957	Patrick J. Venton	Still Life: Kitchen Sink
1959	Terry Frost	Indian Red
1959	Robin Philipson	King and Hunchback
1959	William Scott	Blue Abstract
1959	Frank Avray Wilson	Primordial Image
1961	Sandra Blow	Sphere, Alabaster
1961	Colin Jones	O Flaen Y Cyrddau Mawr
1961	Ron Kitaj	The Red Banquet
1961	Joseph Tilson	Collage 16/W, 1961
1961	David Tindle	Vere Street, W.1.
1961	Evelyn Williams	Two Heads
1963	Sydney Bonner	Looking East, Heading West
1963	Colin Rodney Burrows	Taxi with James
1963	Diana Cumming	Swimming Race
1963	Robyn Denny	Hall of the Ambassadors
1963	Anthony Donaldson	Three Pictures of You
1963	Tess Jaray	Cupola Green
1963	Allen Jones	Hermaphrodite
1963	Michael Kidner	Yellow, Blue and Violet

1963	Stephen McKenna	Collocation
1963	Christopher Paice	Dissected Image
1963	Jeffrey Steele	Gespenstische Gestalt
1963	Sam Walsh	Pin Up 1963 – For Francis Bacon
1963	Alan R. Welsford	Televised Floodlight Game
1965	Adrian Henri	Salad Painting VI
1965	Michael Kidner	Orange, Blue, Green, Pink
1965	Harold Newman	Saltend Jetty
1965	Stuart Walton	Duo No. 3
1967	Graham Boyd	Nation
1967	Adrian Henri	Meat Painting II – In Memoriam René Magritte
1967	Anthony Lessware	Red Letter Day
1967	Joseph Tilson	Zikkurat
1969	Rasheed Araeen	B00/69
1969	Patrick Hughes	Ball on Wheels, Upright Sphere
1972	John Baum	Windermere House, Liverpool
1974	John Walker	Juggernaut II, 1973
1976	Stephen Farthing	Louis XV Rigaud
1976	Derek Johnson	Counterpoint
1978	Jack Smith	The Natural and the Geometric No. I
1985	Joanna Hyslop	Arch
1993	Elisabeth Vellacott	The Expulsion – after Masaccio
1997	Blaise Drummond	Little Western World
1997	Claude Heath	Willendorf Venus
1997	Callum Innes	Exposed Painting, Cadmium Orange on White
2004	Jason Brooks	Cortina